CLAES OLDENBURG: LARGE-SCALE PROJECTS, 1977-1980

A CHRONICLE BY COOSJE VAN BRUGGEN & CLAES OLDENBURG, BASED ON NOTES, STATEMENTS, CONTRACTS, CORRESPONDENCE, AND OTHER DOCUMENTS RELATED TO THE WORKS.

MONUMENTS

BY R.H. FUCHS

RIZZOLI NEW YORK

Cover:
View of the **Crusoe Umbrella** in Des Moines, Iowa,
looking along Locust Street towards the Capitol,
November 1979.

Concept and Organization: **Coosje van Bruggen**
Art Director: **Richard Haymes**
Designer: **Menny Borovski**
Editorial Assistant: **Lucy Flint**
Photo Retouching: **Bob Bishop**
Composition: Text: **Craftsman Type**, Dayton
　　　　　　Display: **Latent Type**, New York
Printing: **Sidney Rapoport**
Editorial Production: **Store Days, Inc.**, New York
　　　　　　　　　　Leo Castelli Gallery, New York

Published in the United States of America in
1980 by:

Rizzoli INTERNATIONAL PUBLICATIONS, INC.
　712 Fifth Avenue, New York, N.Y. 10019

Library of Congress card number: 80-66728.
ISBN: 0-8478-0351-1.

Printed in the United States.

TABLE OF CONTENTS

Time Table
4

Chicago, Illinois
7
Batcolumn

Münster, West Germany
23
Pool Balls

Oberlin, Ohio
39
Plug-buildings or
Alternative proposal for an addition to the Allen Memorial Art Museum

Rotterdam, The Netherlands
45
Screwarch Bridge or
Alternative proposal for a bridge over the Nieuwe Maas

Las Vegas, Nevada
51
Flashlight

New York City
59
Giant Switches

Salinas, California
65
Hat in three stages of landing

Houston, Texas
69
Paintsplats (on a wall by P.J.)

Des Moines, Iowa
77
Crusoe Umbrella

New York City
91
**The Crusoe Umbrella & Flashlight reconstructed
within the Leo Castelli Gallery**

Monuments
96
by R.H. Fuchs

TIME TABLE

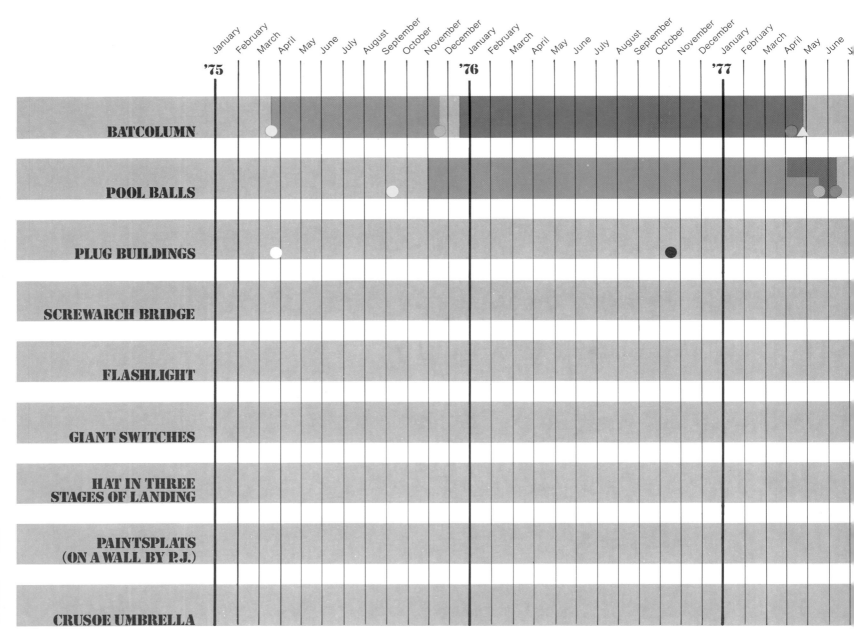

Timeline header months: January, February, March, April, May, June, July, August, September, October, November, December ('75) | January, February, March, April, May, June, July, August, September, October, November, December ('76) | January, February, March, April, May, June ('77)

Rows:
- BATCOLUMN
- POOL BALLS
- PLUG BUILDINGS
- SCREWARCH BRIDGE
- FLASHLIGHT
- GIANT SWITCHES
- HAT IN THREE STAGES OF LANDING
- PAINTSPLATS (ON A WALL BY P.J.)
- CRUSOE UMBRELLA

LEGEND

- ■ Formulation
- ■ Planning & Fabrication
- ■ Drawing
- ■ Etching
- ○ Notification of Commission
- ● Completion of Model
- ● Transportation & Installation
- ○ Removal
- ● Resiting
- ▲ Inauguration
- ▲ Rejection
- ▲ Acquisition

Batcolumn,
for the Social Security Administration,
Chicago, Illinois

- ○ Notified of commission, March 18, 1975
- ■ Formulation, March-November 1975
- ● Completion of preliminary model, November 18, 1975
- ■ Planning and fabrication, December 1975-April 3, 1977
- ● Transportation and installation, April 4-April 13, 1977
- ▲ Inauguration, April 14, 1977

Pool Balls,
for Münster, West Germany

- ○ Notified of commission (for Skulptur exhibition), September 1976
- ■ Formulation, November 1976-May 1977
- ● Completion of model for sixteen **Pool Balls**, May 15, 1977
- ■ Planning and fabrication, April 1977-June 1977
- ● Installation, June 6, 1977
- ▲ Acquisition by the City of Münster, October 10, 1977

Plug buildings,
for Oberlin College, Ohio

- ○ Removal of **Giant 3-Way Plug**, Spring 1975
- ● Resiting of **Giant 3-Way Plug**, October 1976
- ■ Drawing of **Plug-buildings**, January 1978-December 197
- ■ Etching of **Plug-buildings**, January 1979-May 1979

Screwarch Bridge,
for Museum Boymans-van Beuningen, Rotterdam, The Netherlands

- ■ Formulation, December 1977
- ○ Notified of commission, November 1978
- ■ Drawing of **Screwarch Bridge**, January 1978 to present
- ■ Etching of **Screwarch Bridge**, January-June 1980
- ● Completion of model, June 1980 (projected)

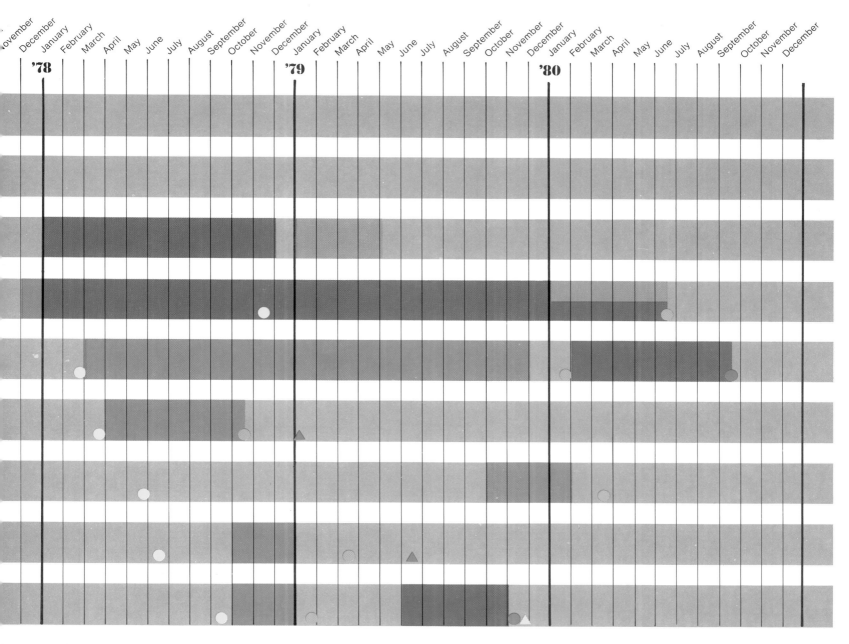

Flashlight,
for the University of Nevada, Las Vegas

Notified of commission, February 21, 1978

Formulation, March 1978-December 1979

Completion of preliminary model,
January 25, 1980

Planning and fabrication,
February-September 1980

Installation, September 1980 (projected)

Giant Switches,
for the CBS Building, New York City

Notified of commission, March 23, 1978

Formulation, March 30-October 1978

Completion of preliminary model,
October 18, 1978

Rejection of preliminary model, January 4, 1979

Hat in three stages of landing,
for the Salinas Community Center,
Salinas, California

Notified of commission, May 28, 1978

Formulation, October 1979-February 1980

Completion of preliminary model, March 1980

Paintsplats (on a wall by P.J.),
for Marshall Field and Co., Houston, Texas

Notified of commission, June 15, 1978

Formulation, October 4, 1978-January 1979

Completion of preliminary model, March 1979

Rejection of preliminary model, May 1979

Crusoe Umbrella,
for the Civic Center, Des Moines, Iowa

Notified of commission, September 1978

Formulation, October 1978-January 1979

Completion of preliminary model, January 31, 1979

Planning and fabrication, June-November 1979

Transport and installation, November 15, 1979

Inauguration, November 27, 1979

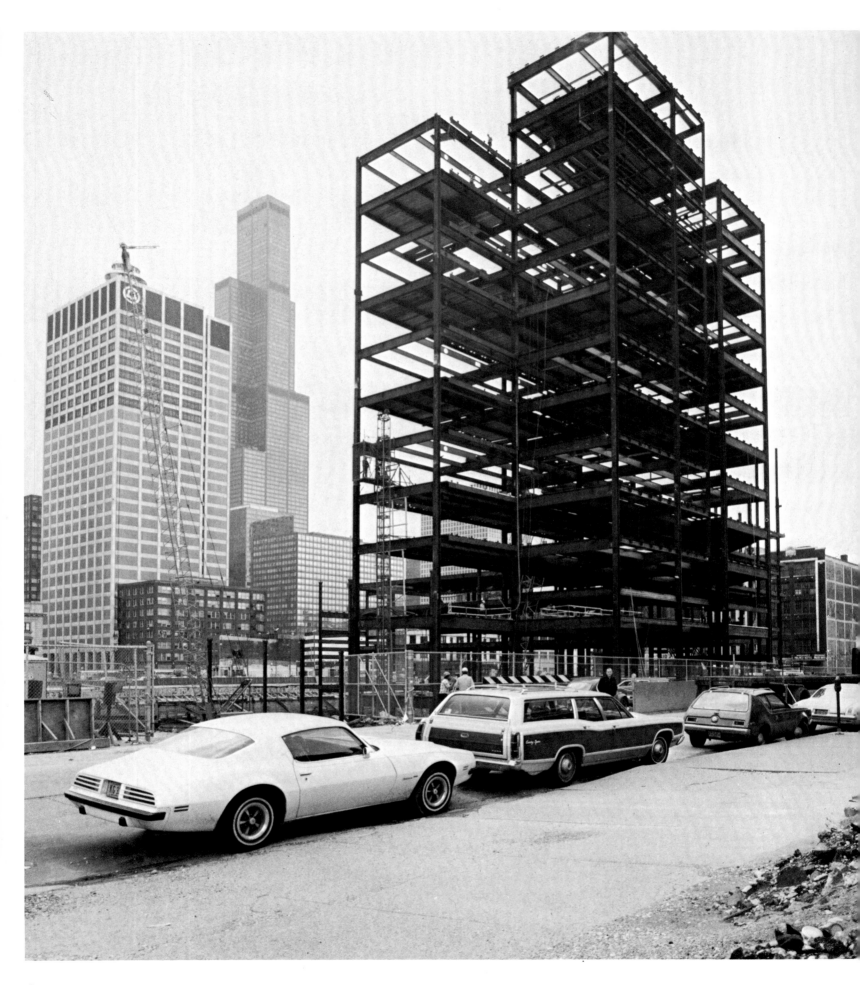

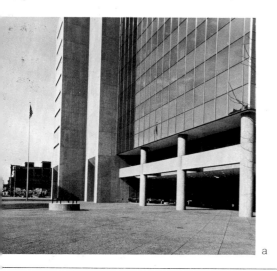

a

b

Site

The Social Security Administration building designed by William R. Baker, of Lester B. Knight & Associates, Inc., under construction, April 4, 1975.

The conditions as described by the architectural firm are:

> The site area is 2.3 acres, a complete city block, located between Chicago's central business district to the east and I-94, the Kennedy Expressway, two blocks to the west. The site, a flat parcel of land, was acquired through condemnation. Chicago's two main railroad commuter terminals are located one and three blocks away. This building, on this site, will have an important effect on the change and future development of the city's near west Loop sector. This is the initial step in the transformation of a once slum area to a significant business-office sector.

a

Social Security Administration building, after completion, November 1, 1976.

The foundation for the **Batcolumn** is at the left.

b

An idealized rendering of the Social Security Administration building.

O
n March 18, 1975, Claes Oldenburg is officially notified by the Art-in-Architecture Program of the United States General Services Administration that he has been selected "to design, execute, and install an exterior free-standing sculpture" for the Social Security Administration Great Lakes Program Center, to be built at 600 West Madison Street in Chicago, Illinois.

G.S.A. commissions are given in cooperation with the National Endowment for the Arts, which appoints "a panel of qualified art professionals, primarily from the region of the project, to meet with the project architect for the purpose of nominating artists." The architect in this case is William R. Baker, of Lester B. Knight & Associates, Inc., and the professionals are: Ann Rorimer of the Art Institute of Chicago, Ira Licht of the Museum of Contemporary Art in Chicago and Tracy Atkinson of the Milwaukee Art Center. The meeting takes place on October 24, 1974, and is conducted by Richard Koshalek.

A contract is signed which takes effect on April 15, 1975. It requires that "the artist shall submit . . . a sketch or other document which conveys a meaningful presentation of the work," and ". . . allow 30 days for the Government to determine acceptability of his proposed artistic expression." The cost of all materials and fabrication of the work will be paid by the artist, who will receive a fee of $100,000 in three installments: $35,000 on approval of the sketch; $35,000 when the piece is completed; and $30,000 following its installation. The G.S.A. in this case agrees to pay the costs of the foundation, estimated to be at least $25,000.

During the following months Oldenburg visits the site repeatedly and tries several ideas before finally deciding on the **Batcolumn**. A preliminary model is built at the Lippincott factory and delivered to the architect in Chicago on November 18, 1975. The proposal is approved and a technique is devised for building the **Batcolumn** of welded steel bars.

The foundation is placed in the spring of 1976, but fabrication of the sculpture is postponed due to a delay in steel delivery. The building opens September 30, 1976, but Oldenburg is granted an extension of 140 days to complete the sculpture. The **Batcolumn** leaves North Haven, Connecticut, on April 4, 1977, arriving a week later in Chicago where it is installed on April 13. The sculpture is formally inaugurated the following day.

On June 22, 1978, the **Batcolumn** is one of two award-winning sculpture entries in the G.S.A's Third Design Awards Program.

The final costs of the sculpture exclusive of legal fees, travel costs, photography and any remuneration for the artist are later calculated as follows:

Development of preliminary model	$ 3,500.00
Materials	34,000.00
Design and fabrication	84,400.00
Transportation	8,500.00
Installation	9,600.00
TOTAL:	$140,000.00

FORMULATION OF THE BATCOLUMN

a

In April 1975 Claes Oldenburg and William R. Baker, architect for the Social Security Administration building, meet for the first time and look at the model of the building, agreeing that the sculpture in front should have a vertical emphasis. However, from the outset Oldenburg relates the choice of a subject more to the city and its architecture than to the building itself:

The plaza in front of the building is large enough so that a sculpture there can have its own space and ambience and need not be pressed against the building, though property lines force the foundation and the sculpture to be placed closer to the building than I had originally intended.

The conditions of the site as seen by the artist are intertwined with his earlier experiences in Chicago. The exploration of a subject in relation to the site entails going back in time, to childhood images and memories of visits to Chicago accumulated in written notes; these have been transformed into "monument" drawings, models and constructions. A selection of notes from 1968-69 gives an insight into the artist's perception of the city landscape:

A city landscape is not a flat space with sky over it, but some spherical condensed form, or like a brain. The colossal object reinserted in the city is the city, in the form of a suitable object.

One stays in a place, absorbing the conditions of it, good or bad and, sooner or later, an image pops up from the surroundings which summarizes it, such as the cemetery...

The real art here is architecture, or anything really that stands up, making a perpendicular to the magnificent horizontal. Any chimney, any tree, any object, (any fireplug). I love all the visible verticals, like a huge cemetery.

Monumentality is really a profession in Chicago, or could be. The space exists for it; history could provide the subjects— my view of "monuments" becomes that conventional here—I am seen hanging around Graceland Cemetery or making pilgrimages to battered Sullivan houses. I almost forget that "monument" as I use it is only a term to convey scale or that I use it ironically.

My Chicago is not about people, past or present, or about objects. It is like all my work, about conditions. People play a role in the work as fabricators of condition, which my organism responds to, registers, records. My work is about Chicago as nature, as forces, but these include (realistically) all forces, human as well as nonhuman, animate and inanimate, visible and invisible, imaginary as well as palpable, at a given time. The "monuments" like the drawings are the condensed record of condition.

a
Lorado Taft's sculpture **Death**, Graceland Cemetery, Chicago.

b
Proposal for a skyscraper for Michigan Avenue, Chicago, in the form of Lorado Taft's sculpture "Death," 1968.
Pen and pencil on postcard and clipping, 28.9 x 23.8 cm.

An example of a colossal object reinserted in the city as a "condensed record of condition."

The view is looking north on Michigan Avenue, with the Playboy building and its beacon to the left and the Hancock building in the center. The tip of the Old Watertower is visible in the lower left of the clipping. Taft's sculpture "Death," which commemorates the first settler of Chicago, is taken out of its context in Graceland Cemetery to become a skyscraper situated on Michigan Avenue south of the Hancock building; its scale is somewhere between those of the other two buildings. The three structures seem to Oldenburg to "link up across Chicago's history." In this proposal the timeless, static and vertical structures of Chicago's architectural skyline are associated with a cemetery. It is "the artist's plea for scale equal to the architect's," one which does not necessarily limit itself to buildings or architectonic geometry: "We need larger things in a more organic mode."

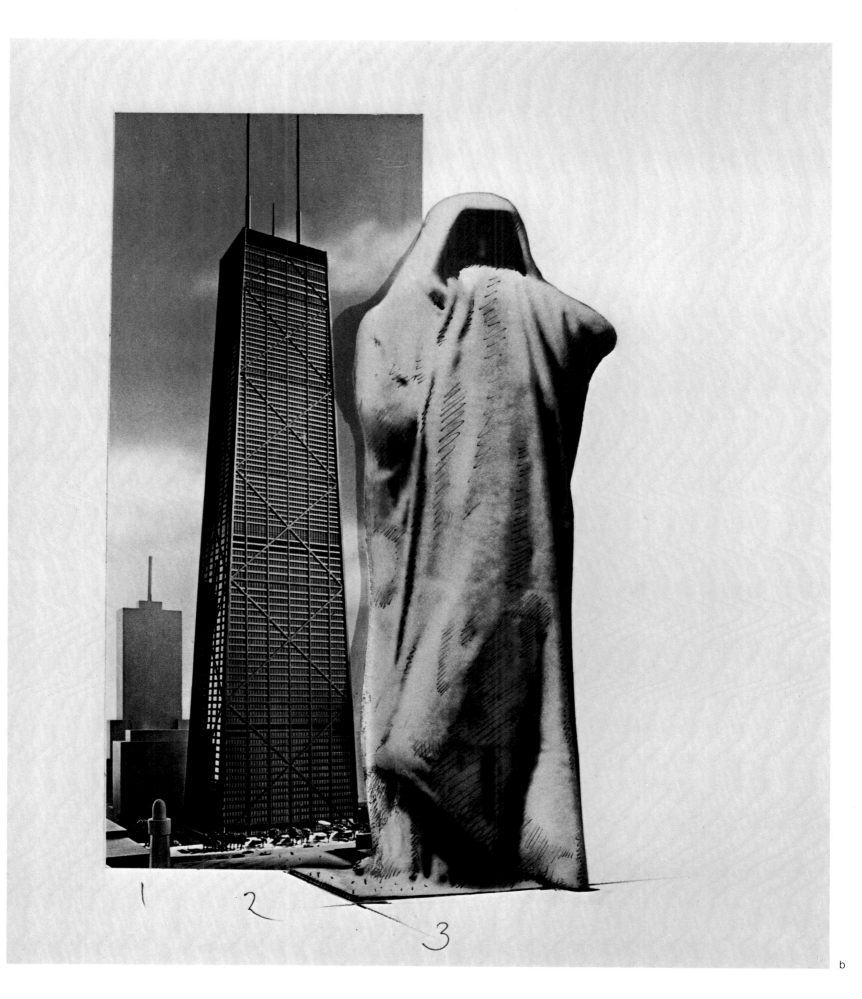

1 2 3

b

9

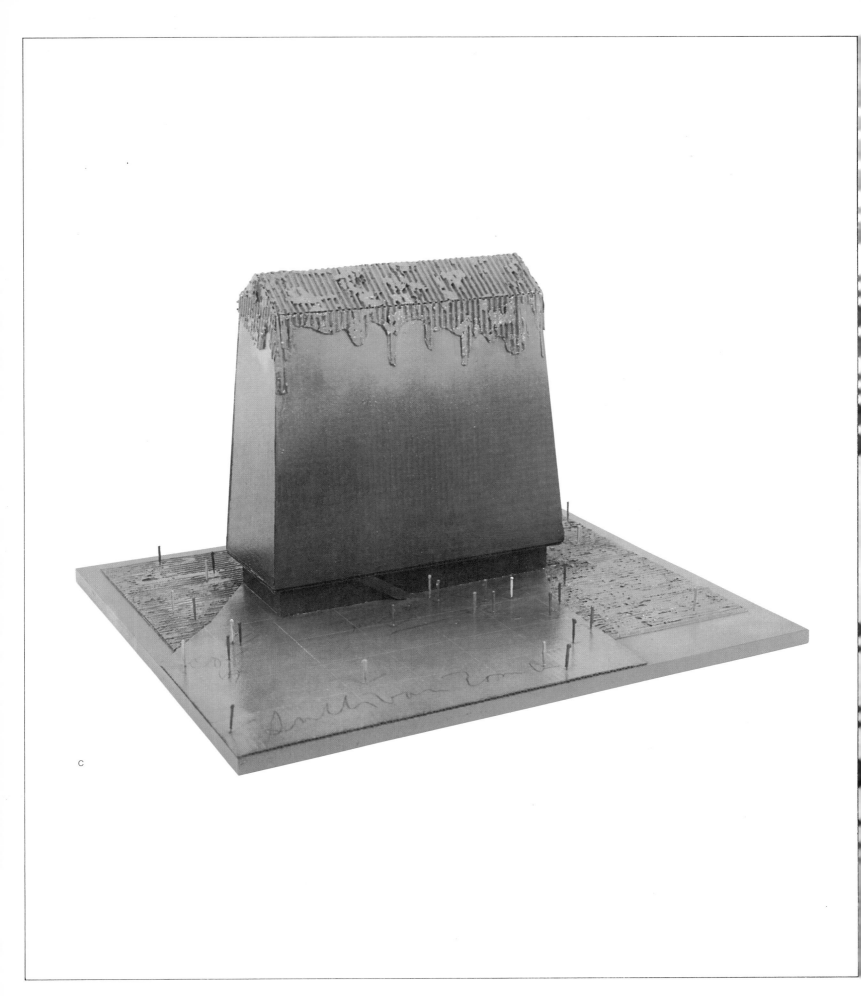

c

c/d
**Feasible monument for Grant Park, Chicago:
memorial to Louis Sullivan - model**, 1969.
Cardboard, painted and shellacked, 35.6 x 59.7
x 68.6 cm.

The peaked roof of the tomb is draped with
vegetation.

The wall of one side of the model is cut out to show
the interior.

One of the buildings demolished on the site
contained terra-cotta panels designed by Louis
Sullivan in 1894, which were saved and later placed
in the cafeteria of the Social Security Administration
building. This reverent attitude towards Sullivan's
architecture and ornaments is ironically expressed
in one of Oldenburg's proposals:

> The Sullivan tomb is based on the anecdote
> that the architect was forced to spend his
> final years sleeping on the floor of a small
> closet under a bare lightbulb which he was
> too weak to extinguish. The tomb is a huge
> brown structure set in the middle of Grant
> Park. One enters by escalators into a vast
> room where one slowly becomes aware of a
> 600-foot-long lying figure of Sullivan. By a
> dim light emanating from an enormous
> light bulb high in the space, one can barely
> make out a complex network of forms
> covering the interior walls and ceiling like
> cobwebs, which are painstaking reproduc-
> tions of the Master's ornamental works.

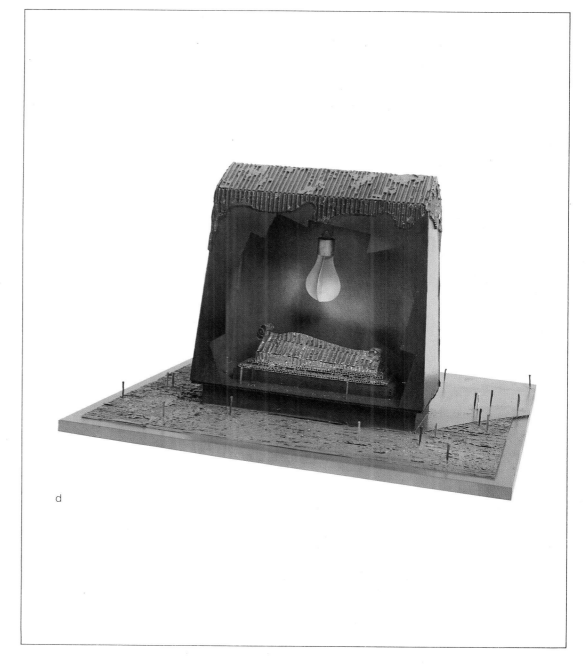

d

11

a

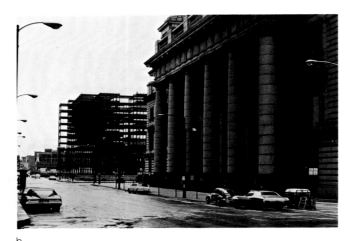

b

c

Monumental vertical structures are integral to Oldenburg's vision of Chicago as expressed in the notes of 1968-69. The problem in 1975 is to find the proper object to contain this vision, an object which would also relate to the site in some way and be practical from the point of view of construction. In a photograph of the site taken by the artist, the neo-classical Greek columns of the Northwestern railroad station occupy a prominent place:

Classical columns are associated in my mind with Chicago, with its architectural pretensions of an earlier period. I have done a drawing for colossal columns of the three Greek orders to be placed in Lake Michigan off Grant Park, and studies comparing Greek column capitals with fireplugs. West of the

site is a small version of a lighthouse on top of the Salvation Lighthouse mission, which picks up in a contemporary and pop—rather silly—version the form of the Northwestern Station columns, which are massive and serious. I like that bracketing of the site. I like to combine contemporary banal and historical classical or archaic style. It gives a time dimension to the work. The area is being cleared now and the lighthouse mission will soon be demolished.

The column is a structure that characterizes the site and its surroundings in both a formal and a cultural sense. Its form must then be expressed in a stereotypical object, a kind of icon from daily life, which will be specific enough to express the conditions of the place. Moreover the object must

be suitable for transformation into art and adaptable to the fabrication process. The first model is a four-headed, inverted **Fireplug Column,** a variation of a Chicago subject from 1968-69. The two heads of the red Chicago fireplug are doubled and lined up with the points of the compass. The east-west heads are placed parallel to Madison Street, the dividing line between north and south in the street numbering system. A congregation of all the city's fire engines is imagined for the inauguration, and a maquette is constructed, but the proposal is eventually abandoned. The next idea is a colossal spoon stuck in the ground, for which a drawing and model are made. Though the spoon is discarded as a subject, the profile of its vertical handle resembles that of a bat, which becomes the final proposal.

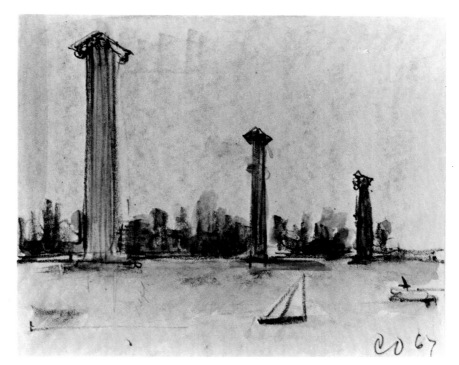

e

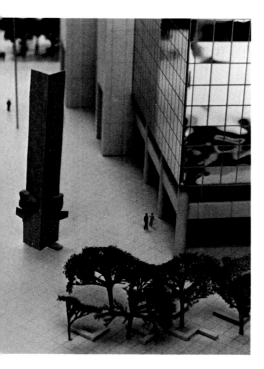

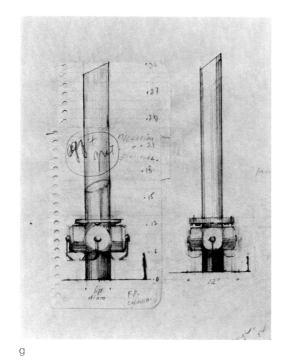

g

h

/b
olumns of the Northwestern Station on
adison Street. Photograph of the site taken by
e artist, spring 1975.

roposal for a skyscraper in the form of a
hicago fireplug, inverted version, 1969.
rayon, watercolor and pencil, 44.5 x 30.5 cm.

d
Colossal fireplug as skyscraper, 1968.
Crayon and watercolor, 34 x 28 cm.

e
Proposal for a colossal monument in the form of
columns of the three Greek orders, in Lake
Michigan off Grant Park, Chicago, 1976.
Crayon and watercolor, 35.5 x 42 cm.

f
Scale study of **Fireplug Column** on architectural
model of the Social Security Administration building,
April 1975.

g
Notebook page: sketch of the Fireplug
Column, 1975.
Pencil, 28 x 21.6 cm.

h
Sketch of a sculpture in the form of a colossal
spoon, 1975.
Crayon and pencil, 35 x 25.5 cm.

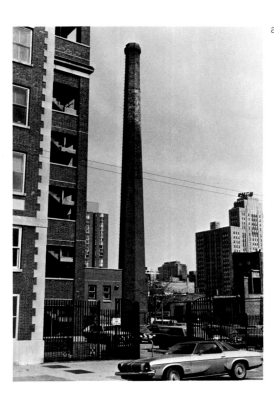

a

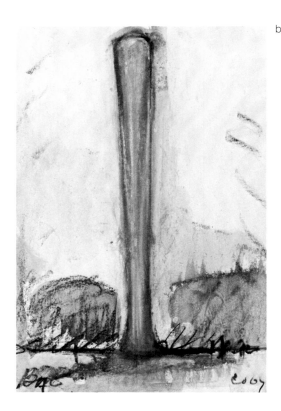

b

c

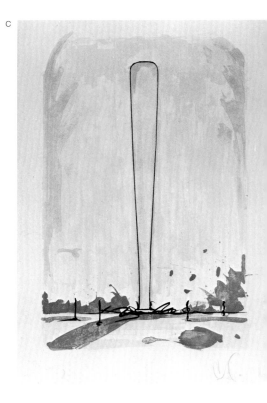

During the summer and fall of 1975 Oldenburg visits Chicago several times to work on lithographs at the Landfall Press. In July, going over the city landscape once again to find a stereotype to combine with the column form, he is especially impressed by chimneys. Although the chimney is too undifferentiated a form for his purposes, he soon associates it with the bat, a subject he happens to be working on at the Landfall Press:

> At first I thought of the bat as a solid structure, but drawing the subject in outline on a litho stone suggested a sort of dematerialization, an opening of the form. It appealed to me to open the surface of an object usually so contracted and dense in order to relate it to the surroundings, as a pure line does, to expose and relate its interior. This also seemed to make a larger scale, and besides was suitable for fabrication, as the practical element is a strong determining factor in art.

The subject of the bat is given further thought and the technique of realizing the sculpture is defined by the artist:

> I had no idea how large the bat should be. If it were reduced to outline it could of course be taller because it would weigh less. I went to the site, but there realized that a pure outline would be too immaterial, almost invisible. A crane at the site suggested the compromise of a linear yet denser construction that would preserve the form of the exterior of the bat, a network, lattice or cage effect. Into my mind popped the image of World War I U.S. battleship towers and the tower of the Parachute Jump in the Coney Island amusement park.

> The crane also suggested the scale of the bat, and I determined that it would reach up to a certain point on the building, later set at about 100 feet.

On his return to New York Oldenburg makes a drawing from which the first preliminary model is built. Painted red and entitled **Batcolumn,** it is presented to the G.S.A. on November 18.

a
Chimney photographed on La Salle Street in Chicago, October 1975.

b
Proposed monument for the southeast corner of North Avenue and Clark Street, Chicago: Bat spinning at the speed of light, 1967.
Crayon and watercolor, 44.1 x 30.5 cm.

The bat subject in relation to Chicago first appears in this drawing of 1967.

> The **Bat** is a coneshaped metal form about the height of the former Plaza Hotel, placed with the narrower end down at the southeast corner of North Avenue and Clark Street. The **Bat** is kept spinning at an incredible speed — so fast it would burn one's fingers up to the shoulders to touch it. However, the speed is invisible and to spectators the monument appears to be standing absolutely still.

> (Proposals for Monuments and Buildings, 1965-69, Chicago, 1969, plate 47)

In July 1975 the subject is adapted to a lithograph.

c
Bat spinning at the speed of light, state I, 1975.
Lithograph, 94 x 63.5 cm.
Printed by Jack Lemon. Published by Landfall Press, Chicago.

d
Tower of Parachute Jump at Coney Island amusement park, N.Y.C.

e
Lattice masts of a U.S. battleship, about 1918.

f
Sculpture by Naum Gabo in front of the Bijenkorf, Rotterdam, 1957.
Metal, 26.2 m. high.

In conceptualizing the **Batcolumn** Oldenburg makes associations with two well-known large-scale works in the modern tradition: the **Endless Column** of Brancusi, whose outline is suggested by the vertical diamond pattern, and the sculpture by

Naum Gabo in front of the Bijenkorf department store in Rotterdam, which, like the **Batcolumn,** is an open structure juxtaposed with a building of closed mass.

g
Notebook page: Chicago towers inverted to make a bat shape, September 1975.
Pencil, pen, collage, 21.6 x 28 cm.

> A bat has no up or down, can be horizontal, vertical or whatever, but I decided that facing the wide end up would differentiate it absolutely from a chimney or any of the existing towers and masts in the landscape. It would also seem to rise into the air rather than sink, which to me seemed to link the form to the sky as a tornado is linked, connecting earth and sky.

> For the foundation I visualized sinking into the earth a single pile identical in size to the **Batcolumn,** a kind of "solid reflection," though invisible. [This idea turns out to be unfeasible. A platform foundation is used instead.]

> The patterns of the **Batcolumn** should refer to the many different grid patterns in the buildings that surround it but those of the **Batcolumn** will be set apart by being diamond-shaped, diagonal, having a kinetic upward-moving direction. The same contrast is achieved in the Hancock building whose giant X'es (I have been told) are not structurally necessary.

h
Preliminary model of the Batcolumn, November 1975.
Painted bronze, 100 cm. high.

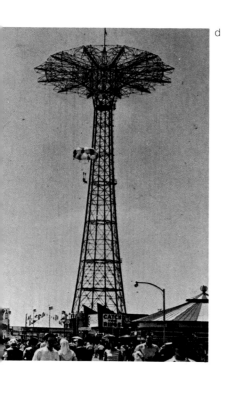

d

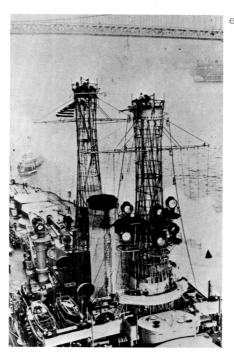

e

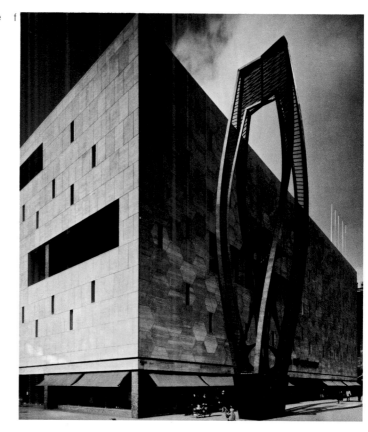

f

3 ats.

chi 1975

g

Reverse
Sens
Frou.

Manhattan

h

15

DESIGN & FABRICATION OF THE BATCOLUMN

In defining the shape of the **Batcolumn** Oldenburg cuts sample bats in half to get a precise idea of their outlines, which he then traces. The bat selected for its contour is a child's bat that is too slender, so the diameter is increased—beyond that of a major league bat in fact—in order to insure that the structure will be massive enough. A wooden version based on his final drawing is turned on a lathe and provides the proportions for J. Robert Jennings, the engineer, to begin his plan of the construction.

Planning: Don Lippincott; structural engineering: J. Robert Jennings; execution: Edward and Robert Giza, Kymball Grant, Joseph Lesko, Paul Pellegrino, Salvatore Savo, Robert Stanford, Frank Viglione, Larry Wallace.

The critical problem is how to achieve a consistent grid pattern within the changing outline of the **Batcolumn.** To lay one direction of the diagonal pattern over the other proves impossible because of the changing diameter of the **Bat.** Eventually a solution is found in a structure of twenty-four vertical bars running the length of the sculpture connected by diagonal bars of the same width which can be extended in length as the diameter increases. The termination of the diamond pattern in the radical curve at the top is defined by Oldenburg in a model.

An eight-foot segment, constituting one-third of the circumference of the **Bat** just above the knob, is built according to the engineer's drawing to give the general appearance of the exterior and to determine the proper thickness of the cor-ten steel bars. After this section is studied it is decided to increase the thickness of the bars from ½ in. to ⅝ in. to lend the **Bat** a more solid appearance.

Once the working method is defined, the cage of the **Batcolumn** is built in a horizontal position; work is begun at the knob and continues towards the top. The cage is supported on a number of cradles so that the sculpture can be rotated during the welding process. Because the structure would warp if it were welded one side at a time, the welding proceeds in stages around the column.

First, the vertical bars are formed in the roller to assume the profile of the **Bat** and are correctly spaced. Twenty-four diagonal units are then tacked around the circumference, and held in place by a second group of twenty-four. This way the welder can return to the first set and affix the pieces permanently, which he does on the inside alone.

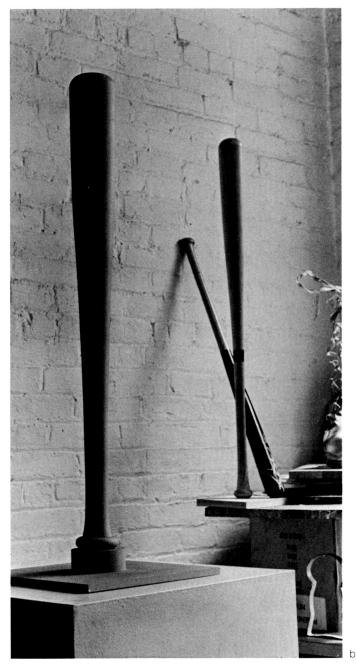

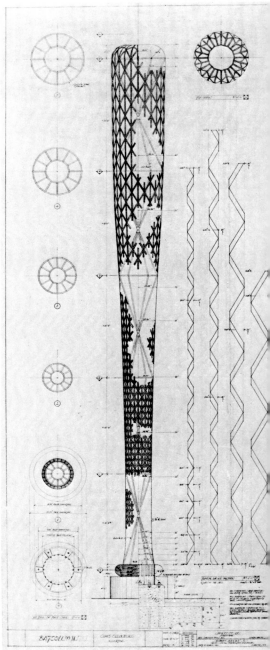

a b c

16

The procedure continues, back and forth, until the whole **Batcolumn** is welded. After the inside is completed the entire outside cage is welded in one operation.

As the construction of the **Bat** proceeds, five diaphragms are installed within the cage to hold its shape. The spacing of the diaphragms is an esthetic decision made by the artist.

Once the exterior cage has been completed, the diaphragms are connected by an inner criss-cross bracing. This interior bracing is not essential for structural reasons but concerns the appearance of the sculpture as defined by Oldenburg. The esthetic function of the bracing in the **Batcolumn** may be compared with the manner in which X-shapes are used in the Hancock building.

The knob of cast aluminum, whose curve has been designed by the artist is fitted around the neck.

Finally, in order to attach the **Bat** to the foundation, the twenty-four vertical bars extending beyond the knob-end are welded to a cylinder, which is then joined to a base plate. Later, at the time of the installation, a cover will be fitted over the cylinder, giving the effect of a base on which the **Batcolumn** stands.

The gray color of the **Batcolumn** was suggested by Coosje in order to emphasize the architectural character of the sculpture and relate it to the buildings of Chicago. The lead color also reinforces the linear silhouette of the piece.

After completion, the **Bat** is sandblasted, painted and prepared for transportation.

a
Study defining the outline of the Batcolumn, 1976.
Pencil, watercolor, tape, 99 x 23 cm.

b
Model defining the outline of the Batcolumn, 1976.
Painted wood on metal base, 92 cm. high.

c
Batcolumn plan by J. Robert Jennings, 1976.
Pencil, 149 x 61 cm.

d
8-ft. test section of the Batcolumn cage made of ½ in. steel bar, August 1976.

e
The Batcolumn being welded together at the Lippincott factory, North Haven, 1977.

f/g
Details of the welded structure of the Batcolumn in the factory yard before sandblasting, 1977.

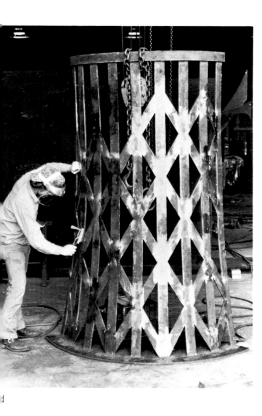

d

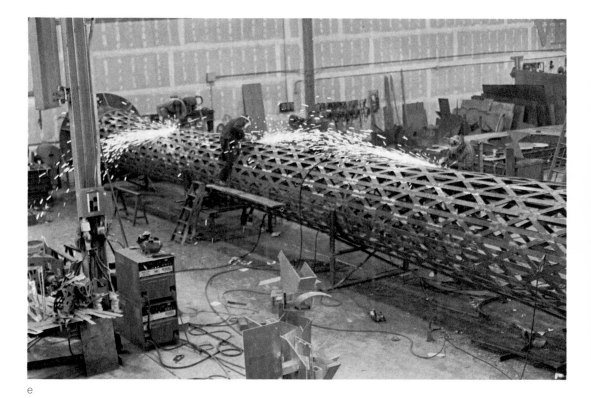

e

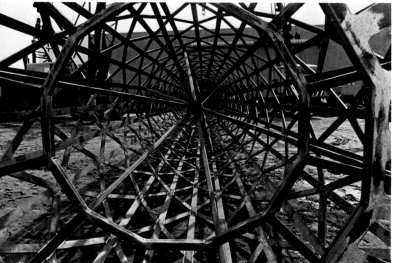

f g

TRANSPORTATION & INSTALLATION OF THE BATCOLUMN

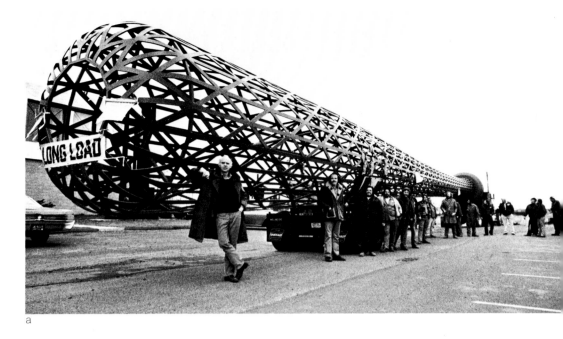

The **Batcolumn** is carried 1,004 miles by an International Harvester Transtar truck using an eight-wheel dolly, with two escort cars. **Bat** and truck occupy 115 ft. of roadway and weigh a total of 67,000 lbs. The truck is driven by its owner, Dave Snavely, and the escort cars by Clarence Werner and his son.

a

b

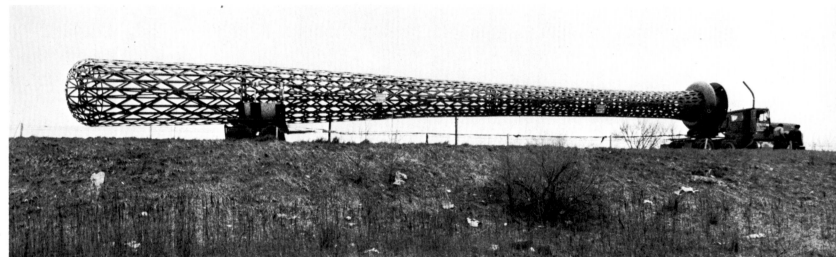

c

a
Formal portrait at the factory just before departure of the **Batcolumn**, April 4, 1977.

b
Traveling along I-91 in Connecticut.

c
Crossing the Calumet River in Chicago.

d
Parked at the site.

e
Following installation. Base is not yet attached.

Up to the present nothing has been done to realize the ambitious plans for development of the area around the Social Security Administration building. At the time of the installation, the Star hotel, a flophouse from the days when this part of Madison Street was known as "Skid Row," was still operating across the street.

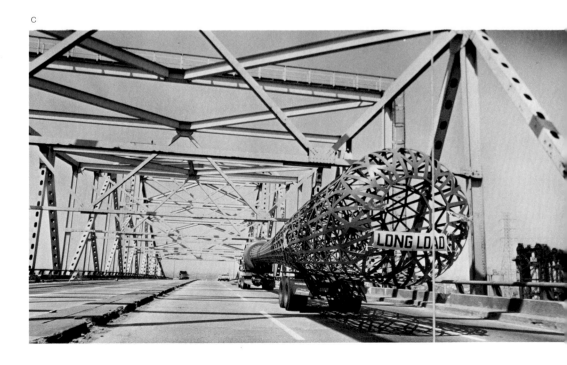

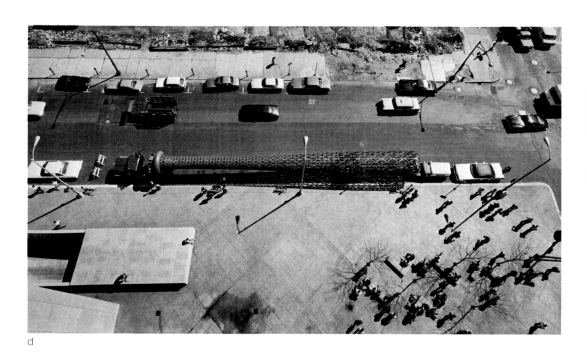
d

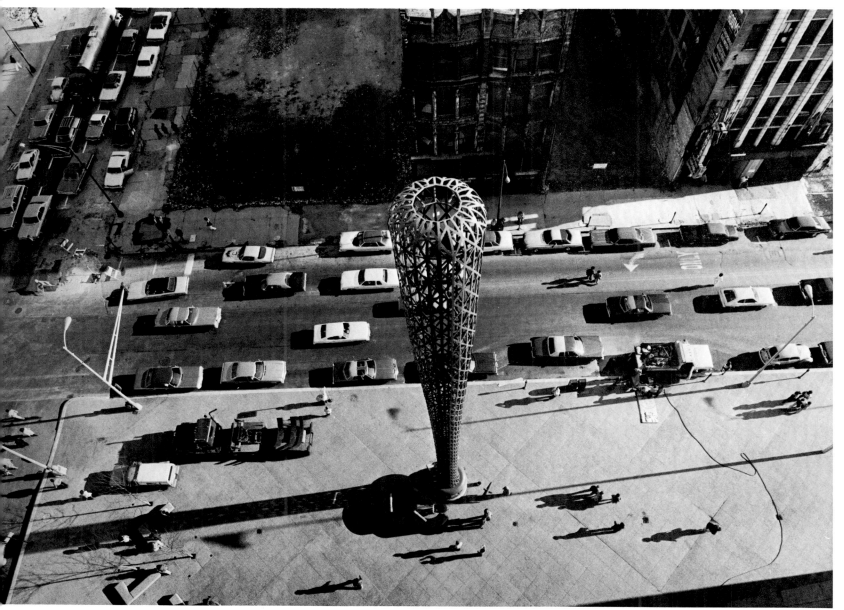

19

a
Batcolumn is hoisted into position by the Midwest Steel Erection Co. The Sears tower is in the background.

b
The **Batcolumn** after installation, April 1977.

The sculpture is composed of 24 verticals and 1,608 connecting units of ⅝ x 3 in. flat bar cor-ten steel. The inner structure is made of 2 in. cor-ten tubing. The knob is made of 24 sections of cast aluminum welded together. The **Batcolumn** is 100 ft. 8 in. (34.3 m.) high. The widest diameter is 9 ft. 9 in. and the narrowest is 4 ft. 6 in. The sculpture weighs 20 tons.

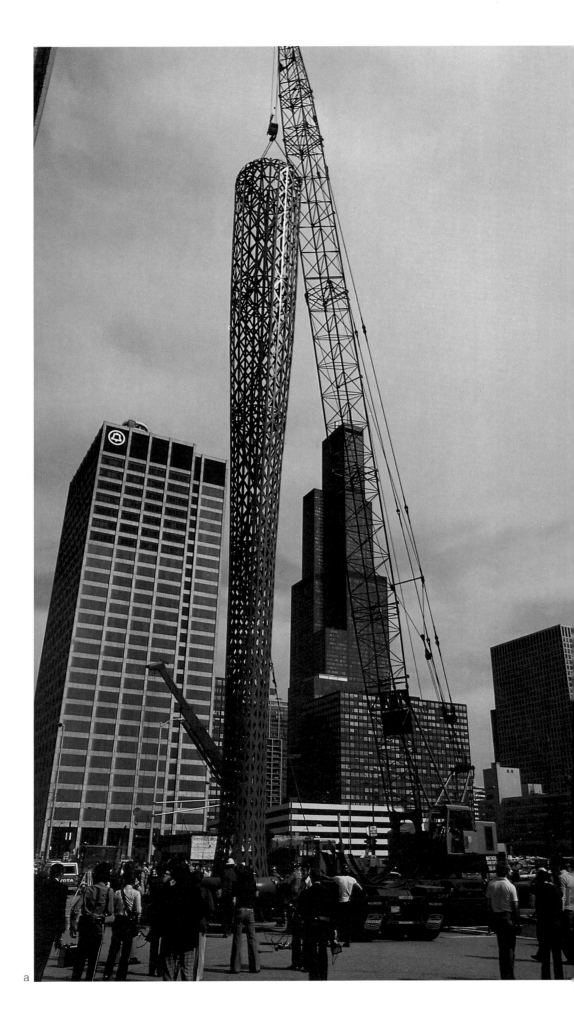

a

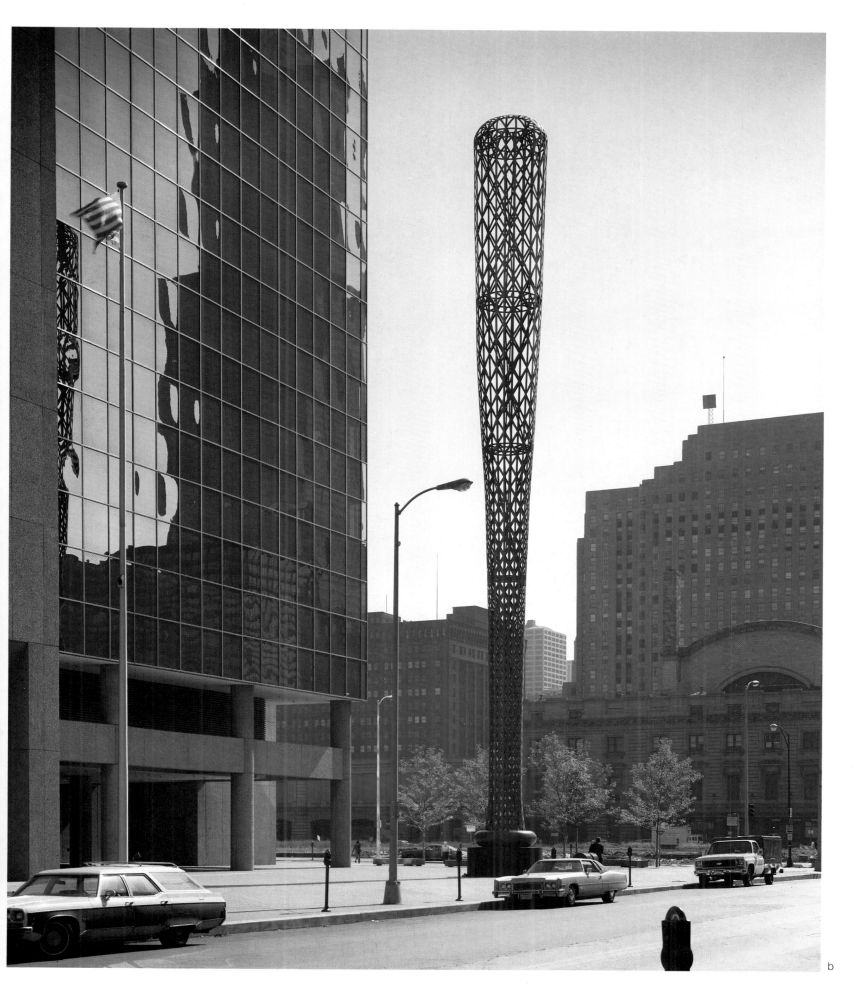

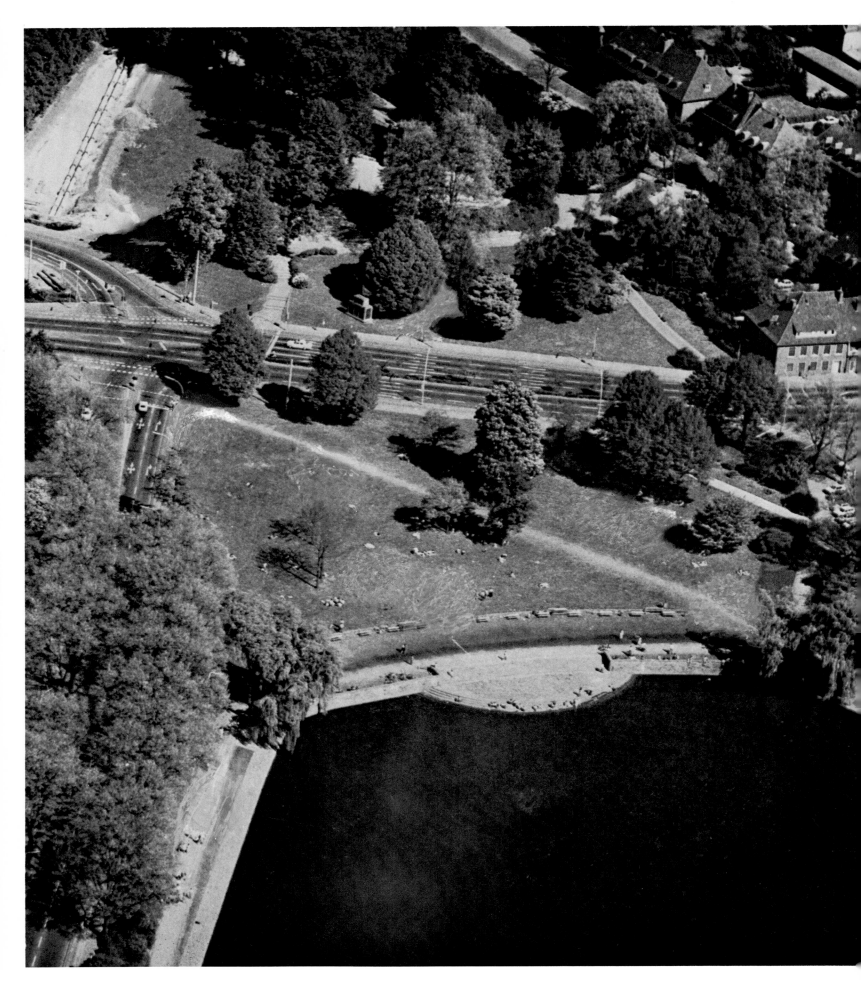

MÜNSTER, WEST GERMANY

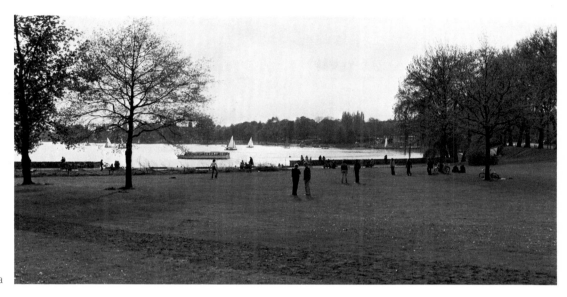

a

Site
Aerial view of the Aaseeterrassen.

The Aaseeterrassen site before the placement of the Pool Balls.

In September, 1976, Claes Oldenburg receives an invitation to participate in the Skulptur exhibition organized by the Westfälisches Landesmuseum für Kunst und Kulturgeschichte under the direction of Klaus Bussmann and sponsored by the Province of Westphalia, the State of North Rhine-Westphalia (through its University) and the City of Münster.

The two parts of the exhibition will be: a) a historical survey of twentieth-century sculpture, to be held in the museum and the Schlossgarten, and b) a contemporary section, directed by Kasper Koenig, for which ten sculptors will be invited to work in situ in the western part of the city (for example, the university grounds, the former grounds of the zoo and the areas around the Aasee lake). Drawings, models and other material related to these works will be shown in the museum.

An honorarium of DM 3,000 will be paid for the proposal, which will remain the artist's property, as will the executed work. The sponsors will pay for materials and the fabrication of the work. In a letter of September 1, 1976, the expenses are limited to DM 20,000. The artist is asked to grant the sponsors first option on the acquisition of the work for a period of eighteen months after the close of the exhibition. In the event of acquisition the production costs will be deducted from the price. "Dematerialization" of a piece shall occur only with the artist's consent and at the expense of the sponsors.

Other artists who agree to participate in the contemporary section are Carl Andre, Michael Asher, Joseph Beuys, Walter De Maria, Don Judd, Richard Long, Bruce Nauman, Ulrich Rückriem and Richard Serra.

During the fall Oldenburg makes a visit to Münster to see the sites that have been made available. In November a workable idea takes shape, the **Pool Balls,** and the Aaseeterrassen is selected as the site.

From November 1976 until May 1977 Oldenburg formulates the idea in models, drawings and photomontages. Meanwhile, at the Hermann Borchard concrete fabricating plant just outside Münster, experiments are undertaken for the realization of a hollow, concrete ball with a 3.5 m. diameter. The difficulty of achieving a perfectly round ball is stressed by the fabricator, and it is

decided that the balls be cast in two halves. The costs of the project will limit the number of balls that can be made within the budget of the exhibition. Dr. Gerhard Isenmann becomes supervisor of the fabrication. Efforts continue to find additional sponsors to cover the costs.

On April 7, 1977, Kasper Koenig confirms that "the mold is in production and the installation of the three balls by July 3rd [the opening date of the exhibition] is guaranteed."

In May 1977 the layout of a pool table area in proportion to the 3.5 m. balls is superimposed on the lawn of the Aaseeterrassen, and the positions of three balls are marked for the placement of foundations.

On June 6, 1977, three **Pool Balls** are installed on the site.

On October 10, 1978, an agreement is concluded between Claes Oldenburg and the Municipality of Münster, whereby the three realized **Pool Balls** and all the models and documentary material on the project will be sold to the City for DM 115,000 minus production costs of DM 50,000. Since the project extends beyond the three balls on the site and in order to show the thinking behind the project, the city agrees to maintain a permanent exhibition of related material in the Museum of the City of Münster. The exhibition will be designed by Oldenburg and a guide to the project will be published by the City.

NOTES ON THE FORMULATION OF THE POOL BALLS

It is a city-wide sculpture show, which offers a choice among many sites. I am taken around the city and my first reaction is to do something for all the sites, to place in each a fragment of some imaginable whole, just as each site may be seen as a fragment of the whole city.

The first step is to find a subject which could be projected on a city scale, suitable to dispersion and distribution of like parts.

Certain earlier proposals could be adapted to this situation, for example, the broken dish of scrambled eggs distributed in different parts of Grant Park, Chicago (1967); the fagends scattered in Hyde Park, London (1966); or the **Proposed**

Colossal Monument for Central Park, N.Y.C.: Moving Pool Balls (1967).

Münster is known for ballooning and aerial photography. Also, the city has a history of bombardments, and there are actual cannonballs still embedded in walls around the city. This suggests that the subject of balls would fit.

My first thought about using all the Münster sites is imaginary: an unlimited number of colossal spheres scattered about the city.

a
Proposed Colossal Monument for Central Park, N.Y.C.: Moving Pool Balls, 1967.
Pencil and watercolor, 56 x 76 cm.

Loose, the balls roll around and bump against the trees and the buildings at the side of the park. A more realistic thought would be to have them motorized like the gigantic, moving structures at Cape Kennedy. They could shift under control, so that every day, as you got up in your apartment overlooking Central Park, the balls would be in a different position. They would be crawling all the time—all over Central Park. The effect is, of course, a pool table. The balls would be different colors but not numbered. They would be hollow inside and could be used for housing or civic business. A whole Washington could be built this way. The positions would change all the time. It would be fun to have a constant movement of such houseballs back and forth across the whole U.S.

(Claes Oldenburg, Proposals for Monuments and Buildings 1965-69, Chicago, 1969, p. 163, col. ill. p. 110)

b
Cannonball embedded in the city wall near the Aaseeterrassen.

c
Colossal sphere on the former zoo grounds in Münster, 1977.
Tempera and pencil on photograph.

d
The imaginary proposal for Münster: an unlimited number of colossal spheres scattered about the city, 1977.
Stickers on aerial photograph.

a

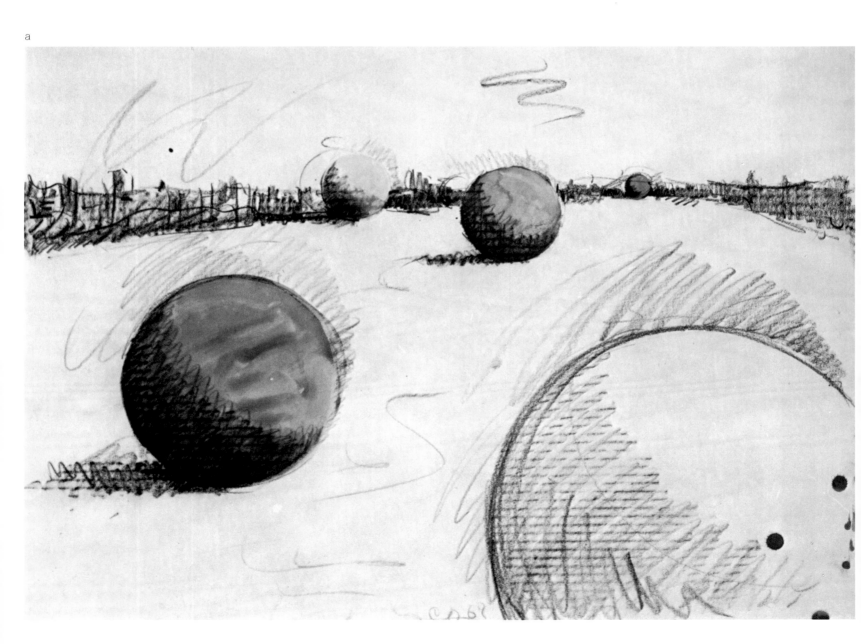

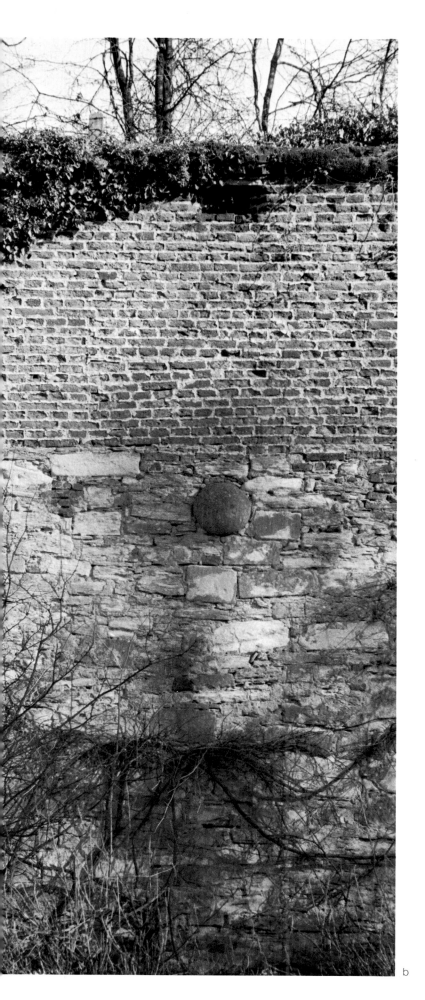

b

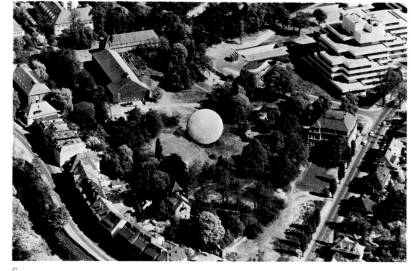

c

d

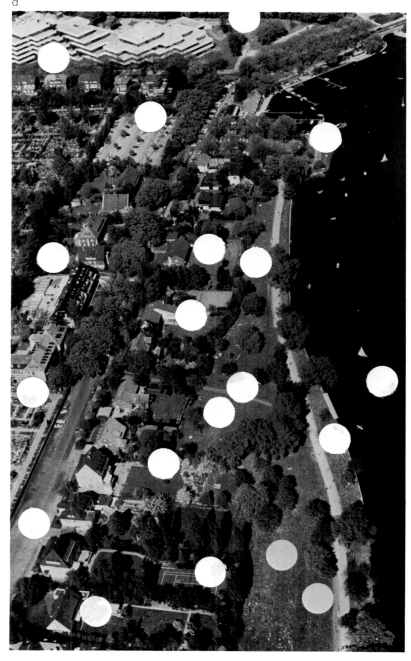

This is a transitional stage between the scattered colossal spheres and a more feasible pool ball project. Pool balls with a diameter of 3.5 m. are tried out in different urban situations, 1977.

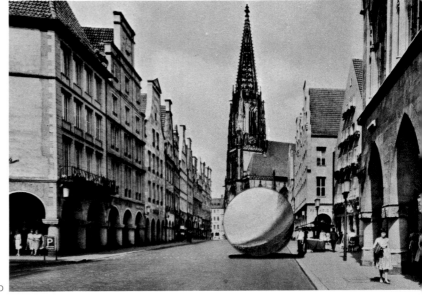

b

a

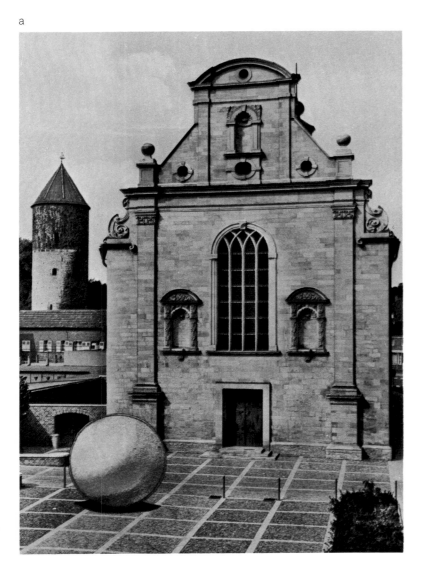

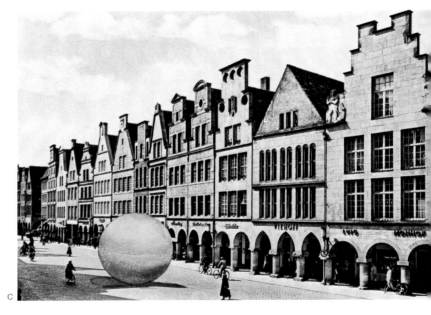

c

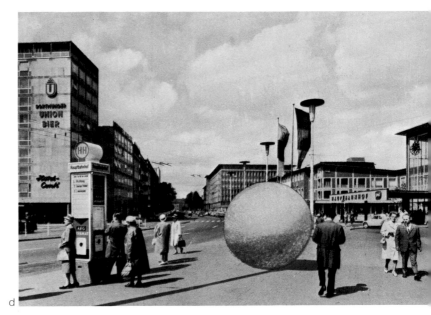

d

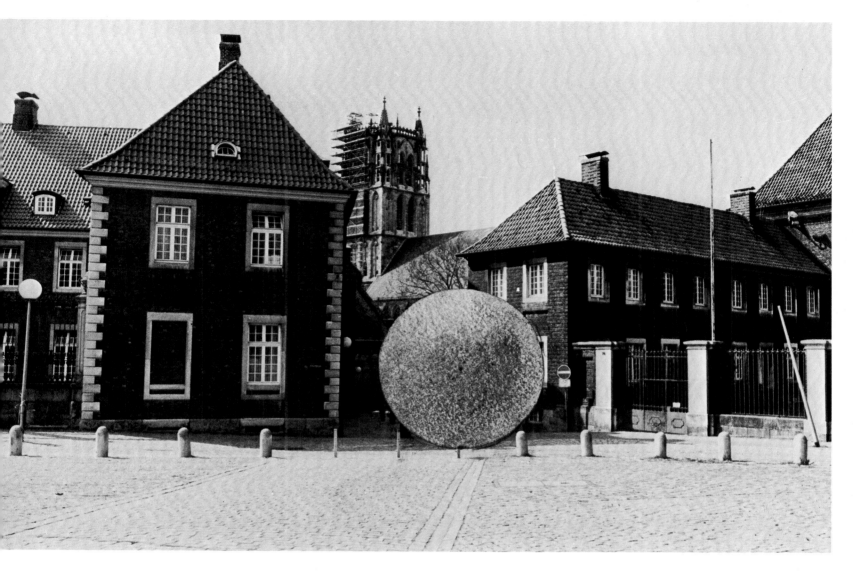

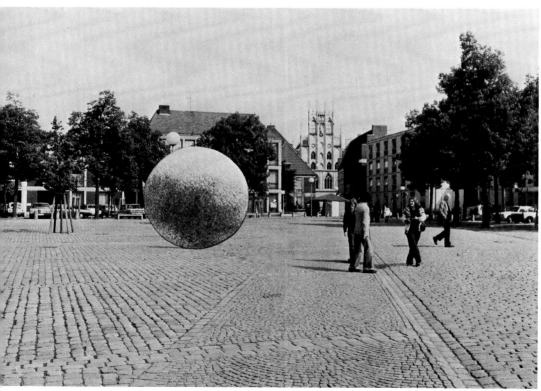

a through f
Tempera and pencil on postcards and photographs
from Münster, 1977.

The feasible proposal consists of a limited number of pool balls in a scattered arrangement. It will be a field sculpture in the form of a pool table with balls, projected onto a particular site in the city.

The balls must be large enough to have some effect on the city landscape.

The size of the balls in relation to the site will be based on the proportions of a standard pool table with balls.

The disposition of the balls can be determined by chance; a rack of pool balls could be broken at a ceremony and their positions superimposed on the chosen area, with some allowance for adjustment to reality.

Or, a typical situation can be chosen: the cue ball at the center of the field and two balls on a forty-five-degree axis in relation to the long side of the table.

The subject is stripped to essentials, to what is needed in this instance: balls in (implied) movement on a field. There are no pockets, no cues, no numbers, no color—except for the green of the grass.

Due to present limitations on fabrication, time and money, it is important to make a piece whose end result can be suggested by a fragment. Thus, the complete set of sixteen balls can be inferred from the three.

a
The dimensions of a standard pool table are measured in a pool parlor in Münster.

b
The decision is made to use the field of grass at the Aaseeterrassen as the site for three concrete Pool Balls. A diagram of the pool table field in proportion to the scale of the concrete balls is superimposed on a map of the site. Three balls from the arrangement are chosen: one ball is at the exact center of the area; another ball is located on a spot one half the distance from the center ball to the edge nearest the lake, on the long axis; and the third ball is placed in a forty-five-degree relationship just east of the second ball.

c
Oldenburg and Koenig mark the positions of the three Pool Balls, May 1977.

d
The positions of the three Balls indicated by stickers on a photograph of the site, May 1977.

e
Model of a field with pool balls, 1977.
Wood, 66.5 x 183 x 364 cm.

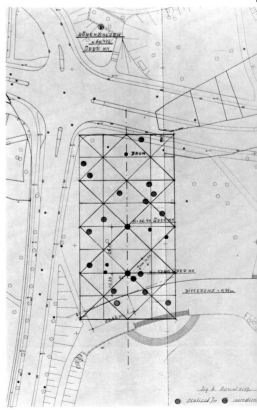

c

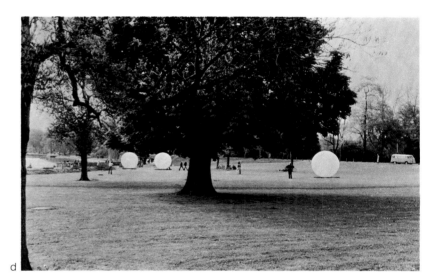

d

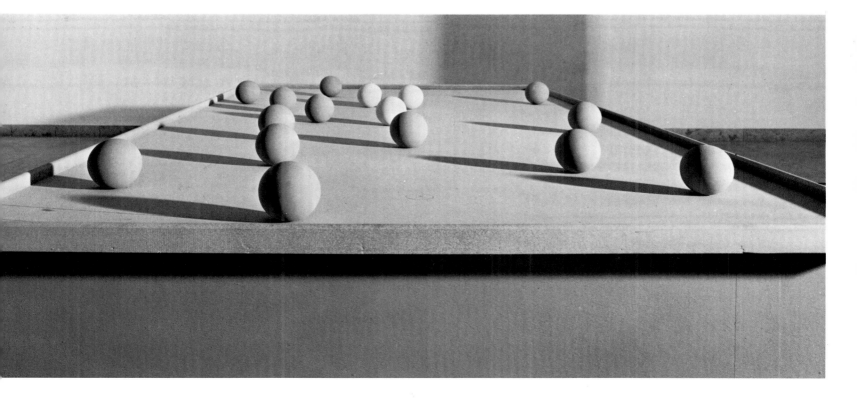

If the funding for the project were to continue and all sixteen balls were made, they could also be shown in a racked situation on the hill at the opposite end of the Aasee, with the cue ball free. After a while they could be scattered again.

a

a
Pool Balls racked on the hill at the southwest end of the Aasee, 1977.
Crayon, watercolor and pencil, 34 x 48 cm.

b
Pool Balls, racked version—model, 1977.
Installed in the Westfälisches Landesmuseum
Concrete, 35 x 156 x 195 cm.

c
Balls scattered on the hill at the southwest end of the Aasee, 1977.
Stickers pasted on photograph.

d/e
Photomontages of the racked version of the Pool Balls in the Schauspielvorplatz, Düsseldorf.

The Schauspielvorplatz in Düsseldorf is also considered for the racked version of the Pool Balls in the fall of 1977. Discussions are held with officials of the city and some experiments are made at the Borchard factory to develop a lighter ball for this site, which is on top of a parking garage. However, the project fails to materialize and is discontinued in March 1978.

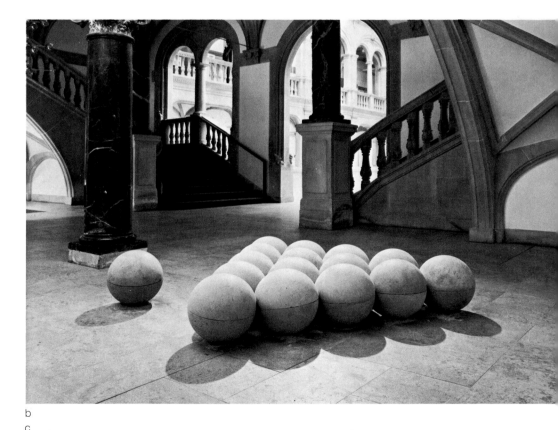

b

c

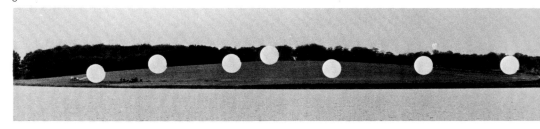

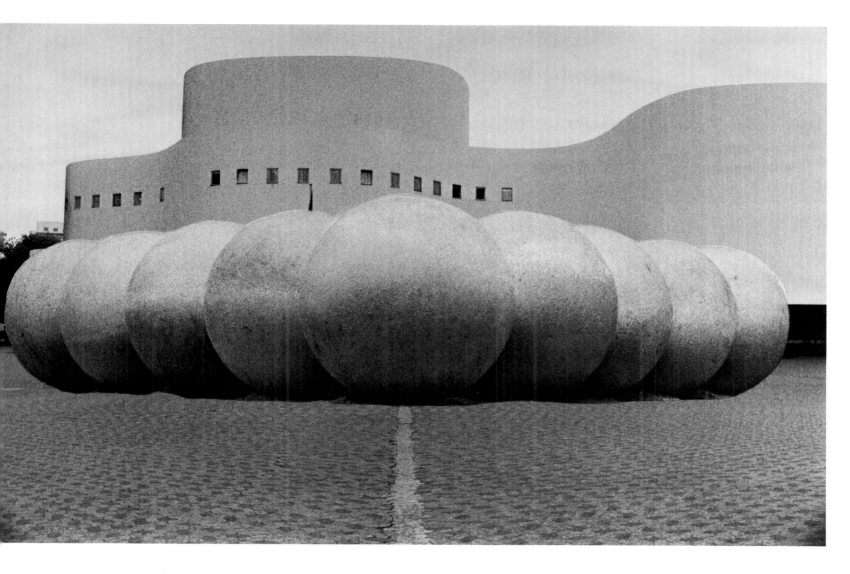

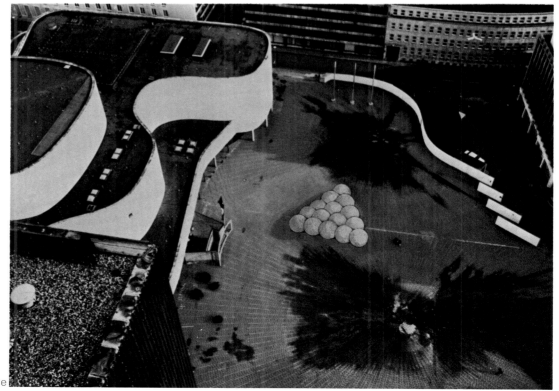

e

FABRICATION
OF THE
POOL BALLS

Stages in the casting of the hemispherical components of the **Pool Balls** at the Hermann Borchard plant in Roxel, near Münster, West Germany, spring 1977.

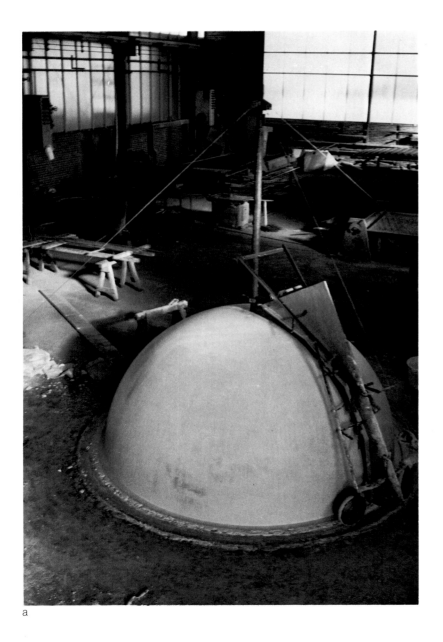

a

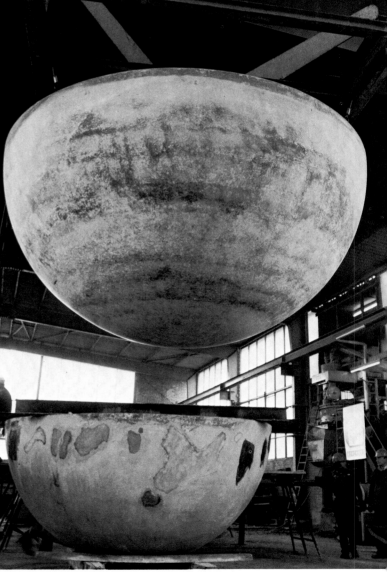

b

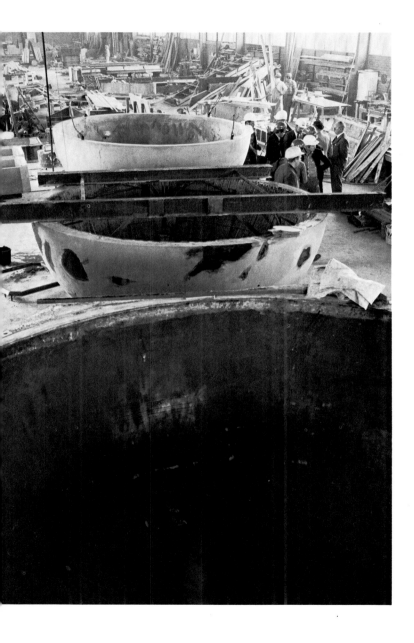

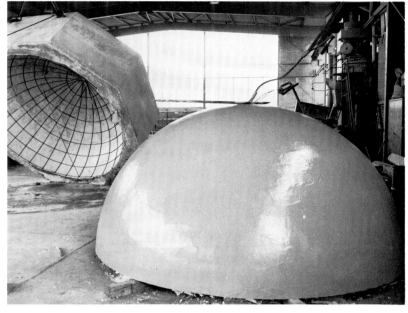

d

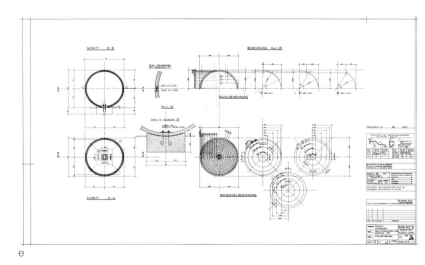

e

haping of the plaster original from which the mold
made.

completed hemisphere is lifted out of the mold.

c
In the foreground, the inside of the plastic mold.

d
The mold backed with concrete is lifted, showing
the structure of reinforcing rods embedded in
the shell.

e
Plan of the **Pool Balls**.

The hemispheres are fitted together at the site, the
beveled edges forming a groove which is later filled.
The bottom hemisphere is bolted to an invisible
foundation which keeps the ball in place.

INSTALLATION OF THE POOL BALLS

a/b
Installation of three **Pool Balls**, June 6, 1977, on the Aaseeterrassen.

c through f
The relationships of the three **Pool Balls** vary

according to the position of the viewer, which contributes to the sense of movement.

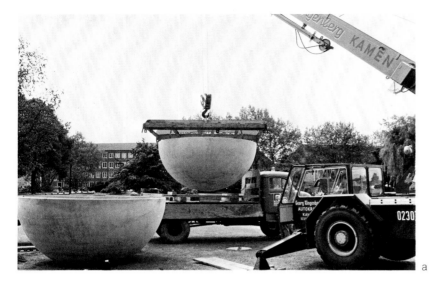

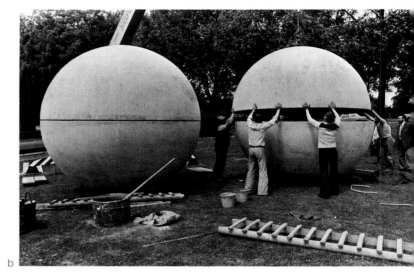

a b

c

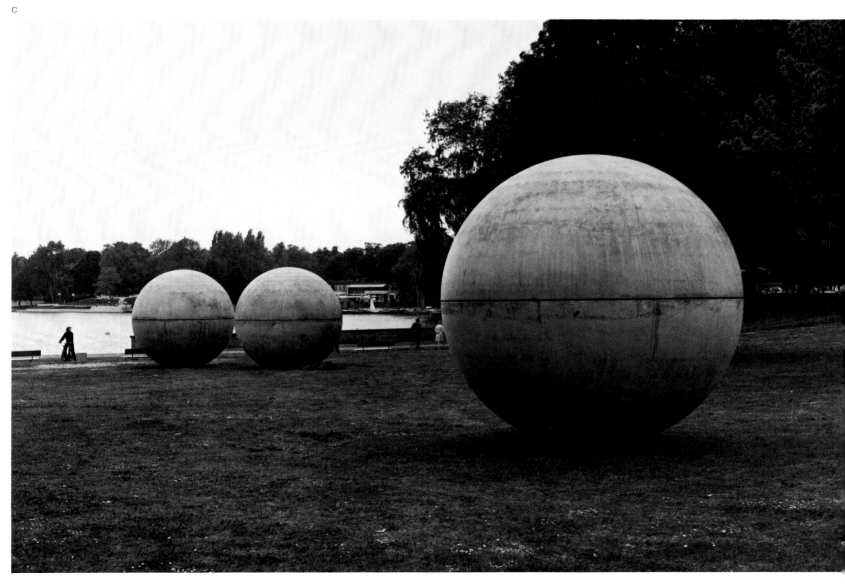

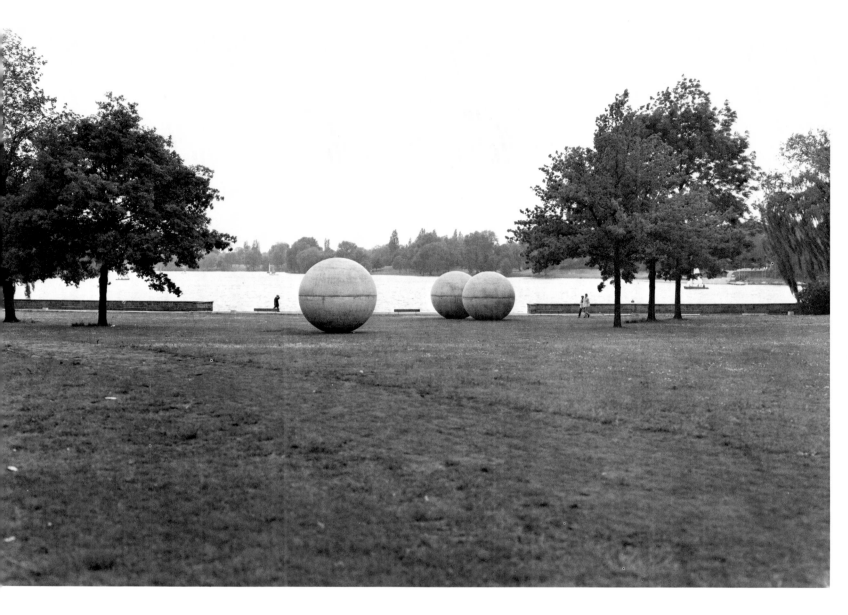

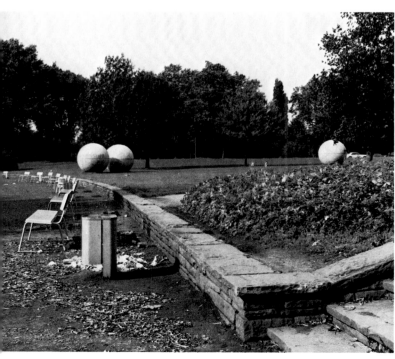

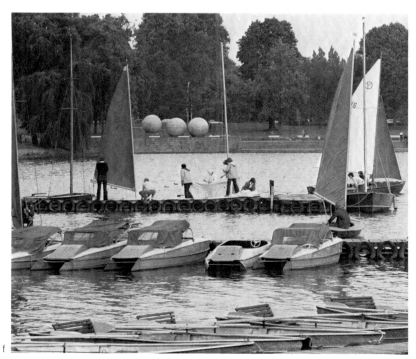

e f

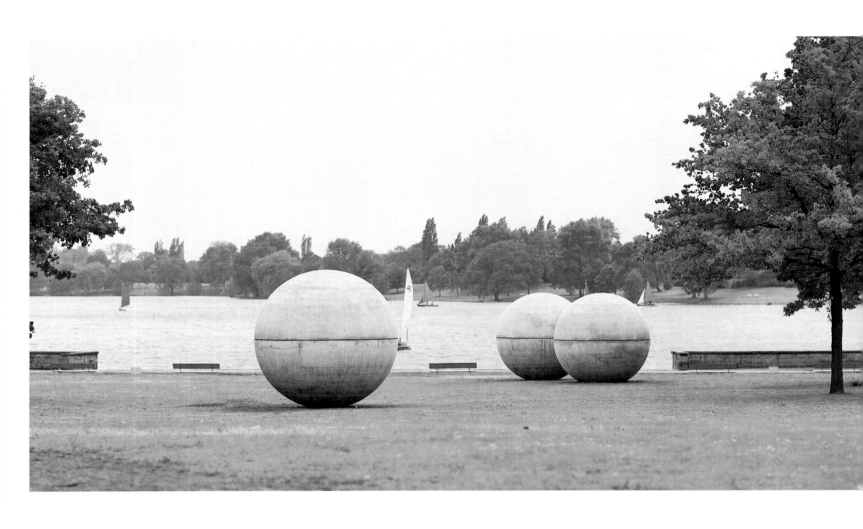

a

a
Three **Pool Balls** at the Aaseeterrassen.
June 6, 1977.

The movement which is so important to the piece is
imaginary, suggested by the position of the **Balls**
and by association with other objects around the site,
such as the constantly moving sailboats on the
Aasee. Seen from a distance, they travel back and
forth across the flat surface of the lake, barely
missing one another, in a way suggestive of the
movement of pool balls on a table. Their sails
supply a color element not found in the **Balls**
themselves and a triangularity that suggests
the rack. If one looks in the opposite direction,
movement is also suggested by the cars of different
colors moving through the intersection. Other
movement around the **Balls** in the park is caused
by people throwing Frisbees or riding bicycles,
or the hot air balloons passing above.

b
Rock concert on the Aaseeterrassen, July 1977.
Before the installation of the **Pool Balls** Oldenburg
notes:

> Will the interruption of the park become a
> factor? Will the element of the "obstacle
> monument" come into effect? With what
> consequences?

On June 6, 1977, the three **Pool Balls** are
installed on the site amid criticism by people
accustomed to using the Aaseeterrassen for their
own purposes. Vandalism against the **Balls** begins
the following day, in the form of political slogans
and drawings like those which already cover
sculptures by other artists, university buildings and
churches in Münster. Later in the summer a group
of students attempt to roll one of the **Balls** into the
Aasee but fail because it is attached to foundations.

After purchasing the **Pool Balls** in 1978, the city
begins to carry out a policy of cleaning them at
regular intervals according to Point 4 of the contract.

Münster represents that it will:

A. Maintain the Sculpture in a state of good
 repair and free of graffiti.
B. Maintain the site of the Sculpture and the
 surrounding area in a neat and first-class
 condition; and see to it that the grass
 immediately adjacent to the three balls is
 neatly trimmed at all times.

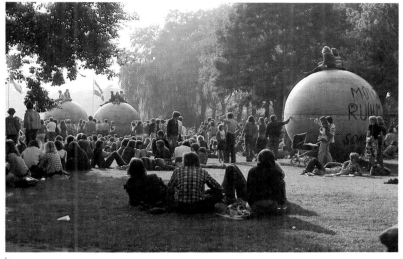

b

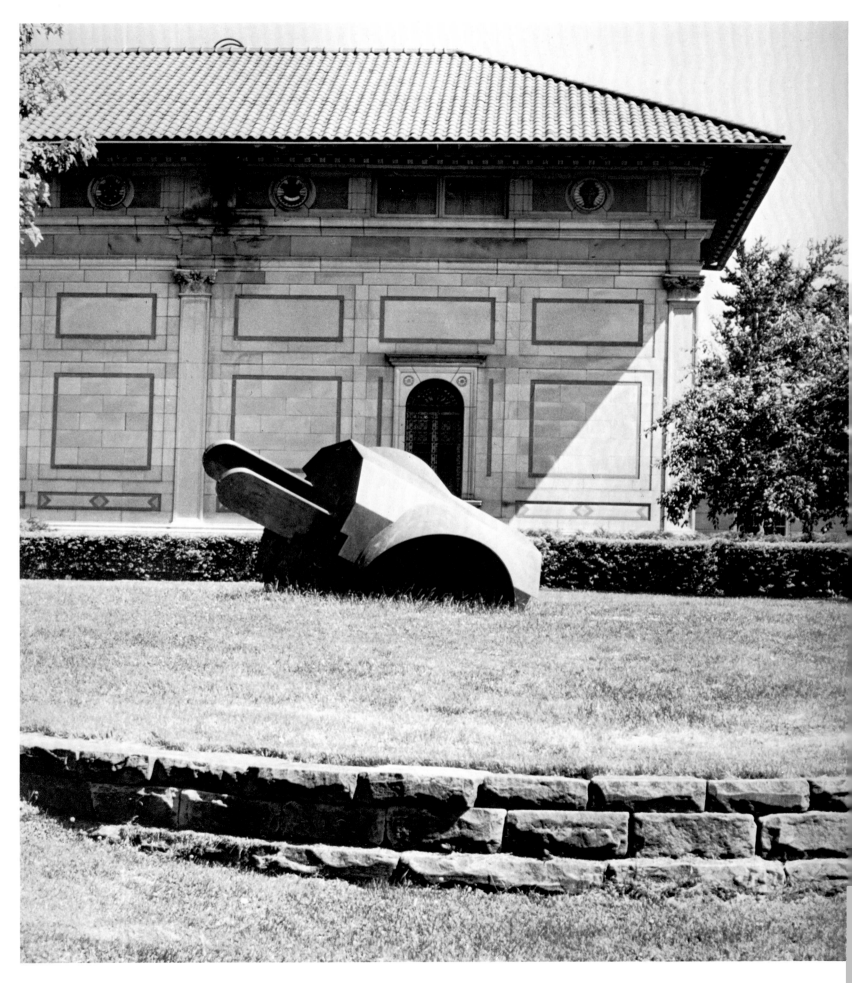

SOME OBSERVATIONS ON OLDENBURG'S ALTERNATIVE PROPOSAL FOR AN ADDITION TO THE ALLEN MEMORIAL ART MUSEUM

b

Oldenburg's Giant 3-Way Plug, 1970, situated beside the Allen Memorial Art Museum, Oberlin, Ohio.
Cor-ten steel and bronze, 297 x 196 x 147 cm.

-Way Plug position studies, 1970.
Objects in painted plaster, 12 x 12 x 12 cm. each.

In 1970 the **Giant 3-Way Plug** is placed on the sloping lawn beside the Allen Memorial Art Museum, which was designed by Cass Gilbert and built from 1915 to 1917 in a Tuscan Renaissance style with Romanesque elements. In choosing this site Oldenburg relates the structural elements of the **Plug** to the architecture of the Museum building.

In her article on the **Giant 3-Way Plug** Ellen Johnson observes that:

> ...the **Plug** matches the Renaissance design in its combination of rectilinear and curvilinear elements and in its strict bilateral symmetry, which is, however, hidden, almost denied, by its partly submerged, dropped position.

(Ellen Johnson, "Oldenburg's Giant 3-Way Plug," Allen Memorial Art Museum Bulletin, XXVIII, 1970-71, p. 226)

Oldenburg uses a plug purchased in an Oberlin hardware store to position the sculpture. Half buried, on a diagonal axis with its prongs upward, the **Plug** appears more as a sculpture than an architectural structure, which in this position would be in some sort of distress. The aggressive diagonal extends into space, increasing the effect of the small-scale sculpture in relation to the mass of the building.

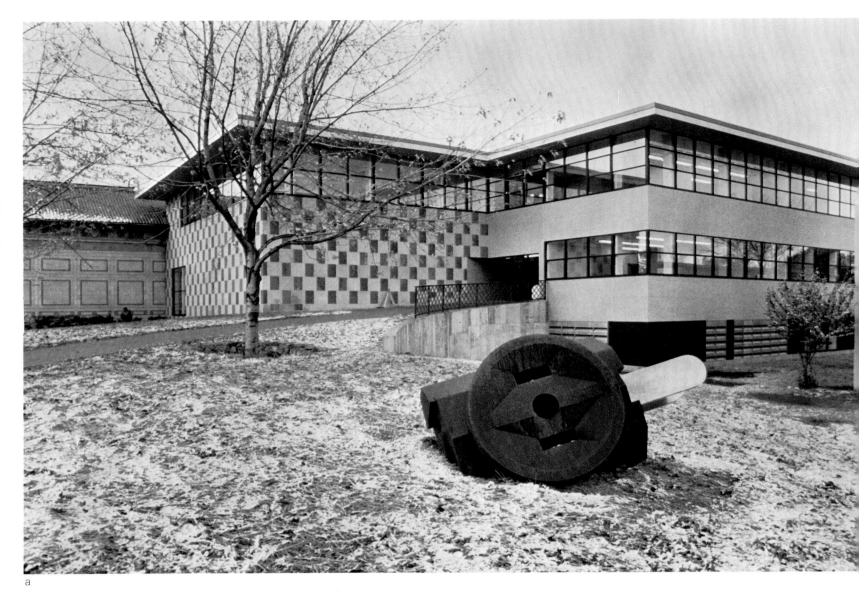

a

Another consideration in placing the **Plug** beside the Museum is to strongly contrast its banal, contemporary context—due to its mass-production origin—with the glorification of the past that the Museum's design suggests.

Oldenburg knows at the time that the **Giant 3-Way Plug** will have to make way for the construction of a new wing. Early in 1975 the **Plug** is removed and placed in outdoor storage, and construction begins on the addition which has been designed by Venturi and Rauch in 1974.

Venturi, writing about the project, discusses the juxtaposition of classical style and contemporary banality he finds in Oberlin, a typical Midwestern town:

> The Art Museum achieves harmony through contrast, heightening the quality of its context through jarring juxtapositions such as terra-cotta friezes with molded plastic signs; della Robbia tondos with Citgo logos; decorative wrought-iron grilles with ginger-bread wooden trellises; pilasters and urns with gas pumps and signs; and a front porch completing a classical axis. Diverse elements give context for, and enhance, each other, like Pop Art beer cans in a white-walled gallery. One Allen Memorial Art Museum does not a Fiesole make; on the

contrary, it makes Oberlin more what it is.

(Allen Memorial Art Museum Bulletin, XXXIV, no. 2, 1976-77, pp. 90, 91)

This observation recalls Oldenburg's intention in placing a sculpture in the form of a common object next to the Museum building.

Venturi's analysis of how the pop elements in the environment and the Museum enhance one another through contrast does not seem to have contributed much to his design of the new wing. He arrives at a solution not out of aesthetic preference as Oldenburg is free to do in his sculpture, but through the practical aims of the building program:

> Our addition, in some ways contrasting with, in other ways analogous to, the original block, is inevitably awkward perhaps, and shows a not too obvious respect for the past. In Italian piazzas similar juxtapositions developed over time in the dense architectural complexes that we admire so much; those complexes make up in guts for what they lose in composition. But our impulse to juxtapose the new with the old in this way came primarily not from an aesthetic preference, but from particular determinants of the site and program. The only site for the new wing was a narrow

sloping strip of land between the Museum and the adjacent Hall Auditorium; there was no room for extension on the north side or in the back.

The development of a plug into a building is a logical step within Oldenburg's work. As early as 1967 English and Swedish extension plugs are expanded into functional buildings: the English one becomes a crematorium and the Swedish one, because of its vaulted cross construction, a chapel.

a
The **Giant 3-Way Plug** in front of the addition by Venturi and Rauch to Cass Gilbert's Allen Memorial Art Museum in Oberlin, after reinstallation of the **Plug** in the fall of 1976.

b
Proposed chapel in the form of a Swedish extension plug, 1967.
Crayon and watercolor, 56 x 76 cm.

c
Building in the form of an English extension plug, 1967.
Pencil, 56 x 76 cm.

b

c

41

A plug is so architectural to begin with, following it to the conclusion of a building is easy. A functional part in a plug becomes a functional part in a building (the outlets become windows, the prongs stairwells, etc.). An object and a building in the modern style change place easily.

It certainly seems that way in the Plug-buildings or an **Alternative proposal for an addition to the Allen Memorial Art Museum, Oberlin, Ohio.** The idea of a substitution of plug for building occurs to Oldenburg in October 1976, when he re-sites the **Giant 3-Way Plug** near the addition to the Allen Art Museum by Venturi and Rauch.

In the etching the sculpture of the **Giant 3-Way Plug** has replaced the addition, becoming a colossal plug or an architectural structure, while the Venturi and Rauch wing is reduced to the scale of a sculpture, becoming a rather unidentifiable box-like shape. The juxtaposition of the Allen Art Museum in a Renaissance style and the Plug-buildings in the form of a banal, contemporary object seems, according to Venturi's theory, to enhance each of them through contrast. A similar opposition is applied by Oldenburg within the design of the Plug-buildings themselves; a balance is achieved between universal, geometric

shapes and the stereotypical organization of these elements which makes them recognizable as a plug. The design of the Plug-buildings matches and contrasts with the Allen Art Museum just as the sculpture of the **Giant 3-Way Plug** does. Although Oldenburg is not bound to a building program, the possibility of adding Plug-buildings in any direction linked by their prong "corridors" is a practical solution for expansion of the Museum.

Despite the enormous shift in scale from real to colossal, one's recognition of a plug could give the building a look of intimate familiarity. On the other hand, the proposal could be an ungraspable and surprising curiosity, reminiscent of the description in Jonathan Swift's "Voyage to Lilliput" of two diminutive people finding the pocket-pistol of the man-mountain Gulliver:

> In the large pocket of the right side of his middle cover...we saw a hollow pillar of iron about the length of a man, fastened to a strong piece of timber, larger than the pillar; and upon one side of the pillar were huge pieces of iron sticking out, cut into strange figures, which we know not what to make of.

For the time being, the alternative proposal will remain in the realm of unfeasible projects. Faced with Oldenburg's vision one has to identify oneself

with Gulliver, looking down at a Lilliputian world and seeing Plug-buildings rendered in a scale close to that of an actual plug.

CvE

a
Allen Memorial Art Museum, west elevation with addition by Venturi and Rauch, 1974.

b
Elevation showing the 3-Way Plug as an addition to the Allen Memorial Art Museum, Oberlin, Ohio, 1977.
Pencil and clipping, 23.5 x 33.5 cm.

This early study shows the Plug serving two functions and in two scales.

c
An alternate proposal for an addition to the Allen Memorial Art Museum, 1979.
Hard and soft-ground etching with aquatint, 86 x 93 cm.
Printed at Aeropress, N.Y.C., by Pat Branstead, Gretchen Gelb, Sally Sturman.
Published by Multiples, Inc., N.Y.C.

a
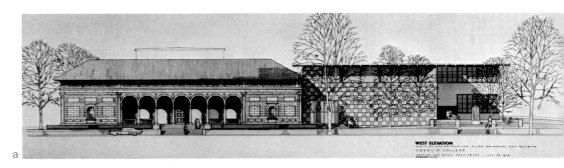

b
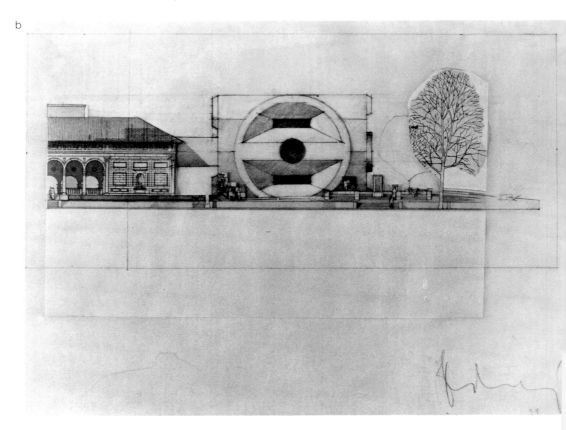

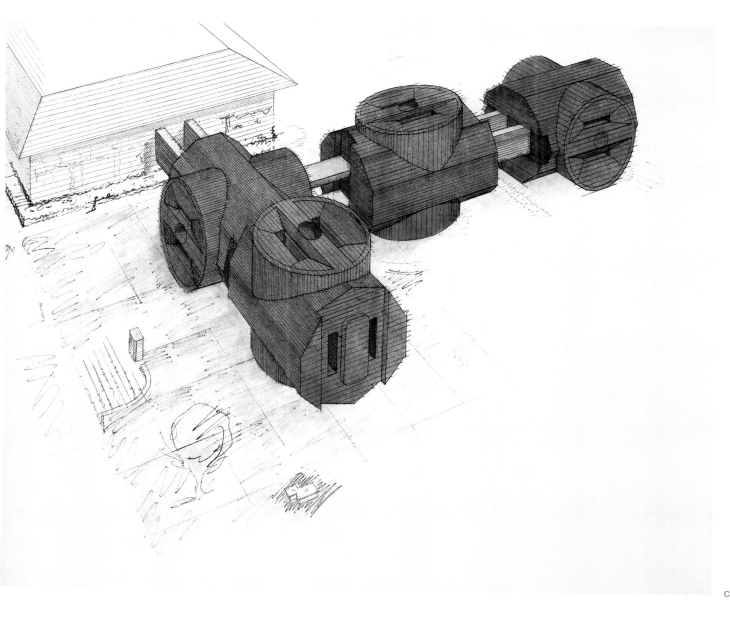

c

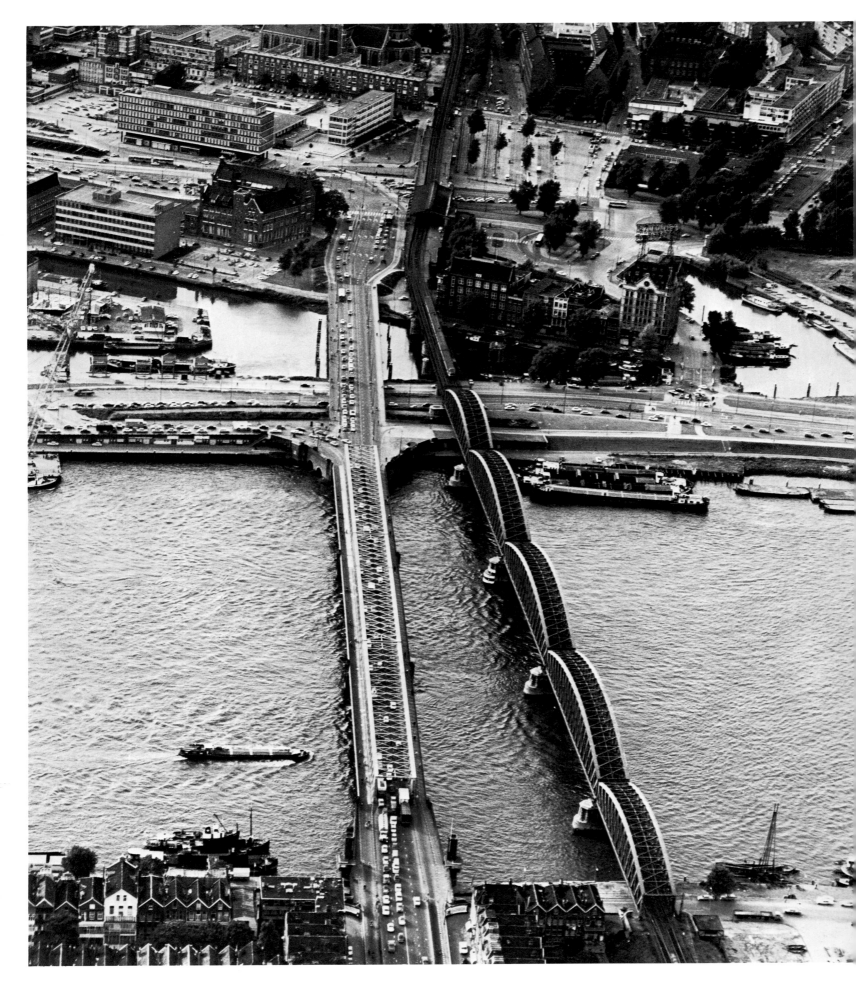

44

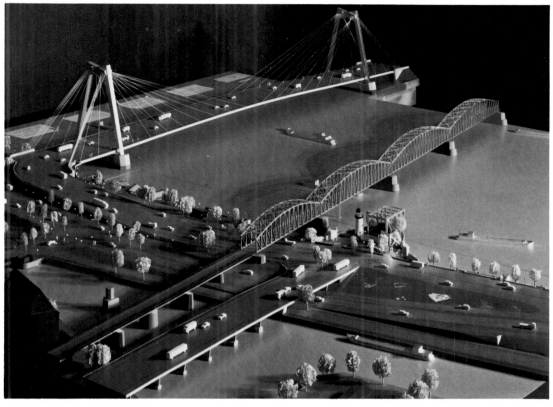

a

Site
View of the bridges over the Nieuwe Maas,
Rotterdam, 1979. The bridge on the left is to be
replaced; the railway bridge on the right will remain.

The model of the new Willemsbrug over the Nieuwe
Maas in Rotterdam.

In December 1977 Oldenburg, who has been
living in The Netherlands, hears about a
bridge to be built across the Nieuwe Maas
in Rotterdam. This project provides an ideal
site for his visionary concept of a bridge in the
form of a **Screwarch**, a subject he has sketched
in a series of drawings during the past year.

On his return to the United States in the beginning
of 1978, the artist starts drawing the **Screwarch
Bridge.** For a commission by the Museum
Boymans-van Beuningen in Rotterdam, conveyed
in November by its director Wim Beeren, Coosje
suggests a group of works that show different
approaches to the theme of the **Screwarch.**
Oldenburg proposes making a four-meter-high
sculpture of the **Screwarch,** a model of the
Screwarch Bridge and related drawings and
prints. In January 1980 a model and large etching
of the **Screwarch Bridge** are begun. The design
of the bridge now includes two **Screwarches**
whose points meet to form a V in the center of
the river. Plans, elevations and photographs
are obtained from the Rotterdam planning office
to aid in the realization of the project.

FORMULATION OF THE SCREWARCH

The subject of the screw first appears in a cardboard model of 1969 that shows a screw rising from the ground in three stages. The model is done at Walt Disney Enterprises, where Oldenburg works briefly, as part of the Art and Technology program of the Los Angeles County Museum of Art. The rising screw is further developed as a large-scale sculpture to be placed on the grounds of the Gemini G.E.L. print workshop in Los Angeles. A kinetic model is built, but the sculpture is never carried out. Thereafter, in 1975, the mold from which the model was made is used to cast an edition of **Soft Screws** in urethane. A bent version of one of these serves as the original for an edition of four

bronze castings of the **Screwarch**, made under the supervision of Jeff Sanders. Two extra castings become part of the **Model of the alternate proposal for a bridge over the Nieuwe Maas, Rotterdam,** or the **Screwarch Bridge.**

a
Soft Screw, 1976.
Cast urethane on a wooden base, 116.2 x 29.5 cm.
Edition of 24. Gemini G.E.L., Los Angeles.

b
Screwarch model, 1977-78.
Bronze, 45 x 78.7 x 28 cm.
Edition of 4.

c
Arch in the form of a screw for Times Square, N.Y.C., 1975.

Lithograph, 171.5 x 102.9 cm.
Printed by Charly Ritt and Barbara Thomason.
On its first site, the Screwarch joins the "traffic islands" in the center of Times Square, spanning one of the cross-town streets.

d
Screw-shaped pumps are used to raise water from one level to another throughout The Netherlands. This example was photographed at Kinderdijk, near Rotterdam, December 3, 1977.

e
Notebook page: Sketch of Screwarch for a Rotterdam site, 1976.
Pen on envelope, mounted on paper 28 x 21.6 cm.

In June 1976 Oldenburg moves to Deventer, where he sets up his studio. The subject of the **Screwarch** is affected by his interest in the many bridges of The Netherlands. The two arched structures naturally merge to form the concept of a **Screwarch Bridge.**

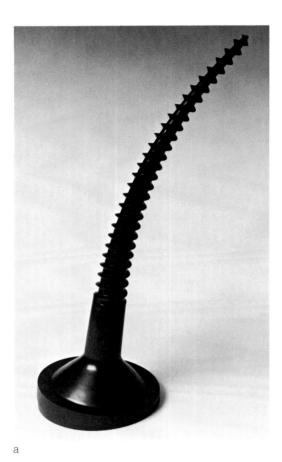

a

b

c

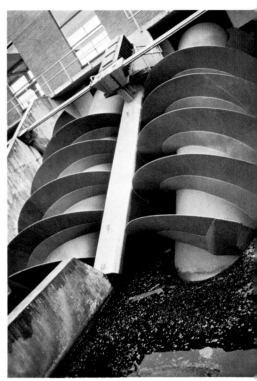

d

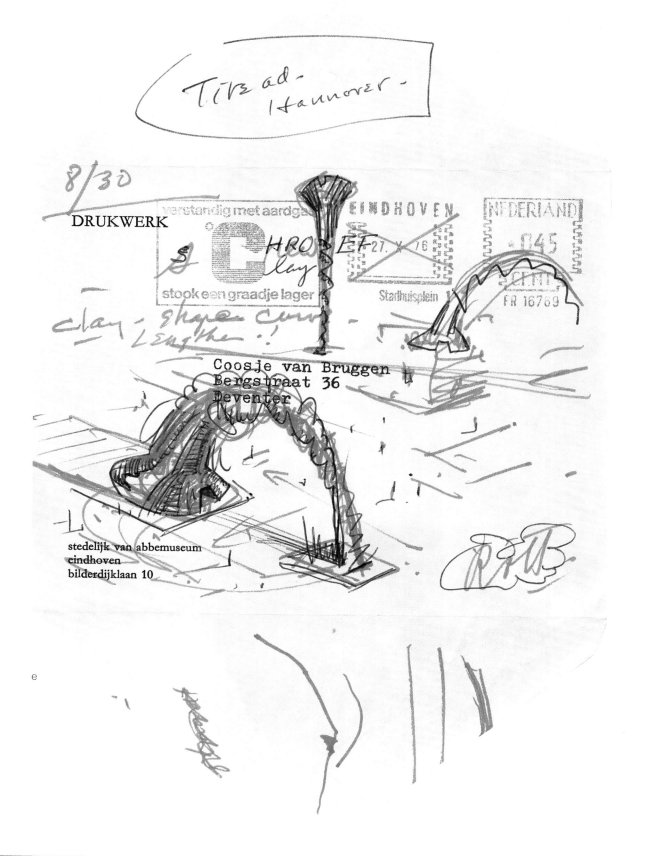

Tire ad.
Hannover.

8/30

DRUKWERK

verstandig met aardgas EINDHOVEN NEDERLAND

stook een graadje lager 27. X. 76 .045

Stadhuisplein 1 FR 16769

Coosje van Bruggen
Bergstraat 36
Deventer

stedelijk van abbemuseum
eindhoven
bilderdijklaan 10

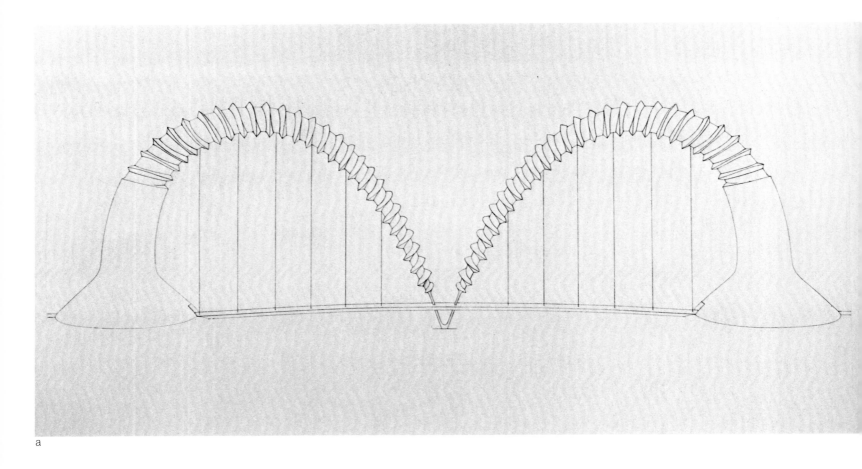

a

a
Screwarch Bridge, 1980.
Etching, early state, 61 x 129.5 cm. (plate size)
Printed at Aeropress, N.Y.C., by Pat Branstead,
Sally Sturman. Published by Multiples, Inc., N.Y.C.

b
Model of the Screwarch Bridge in progress,
April 1980.

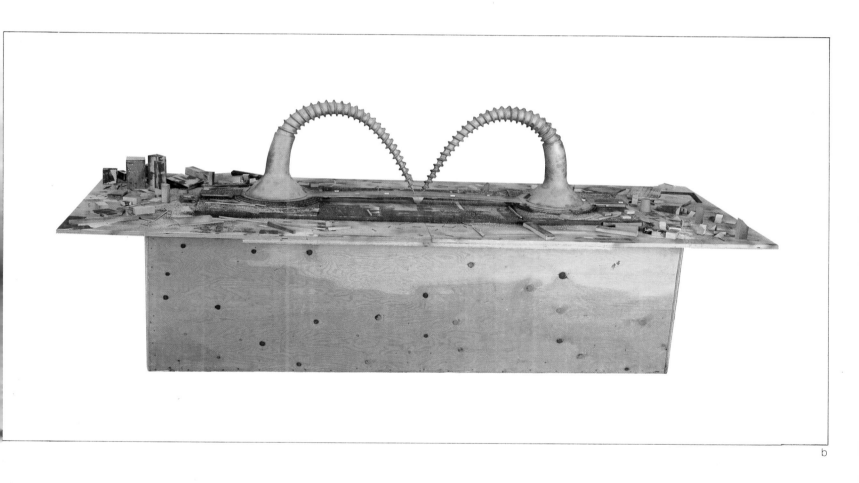

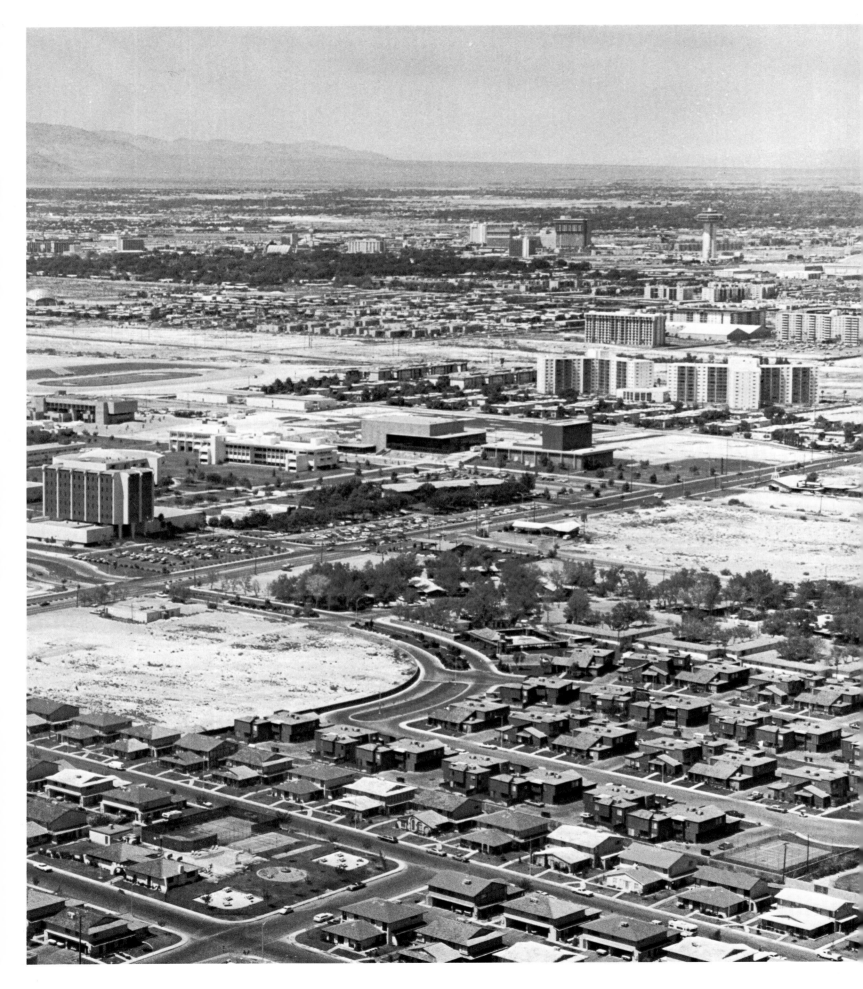

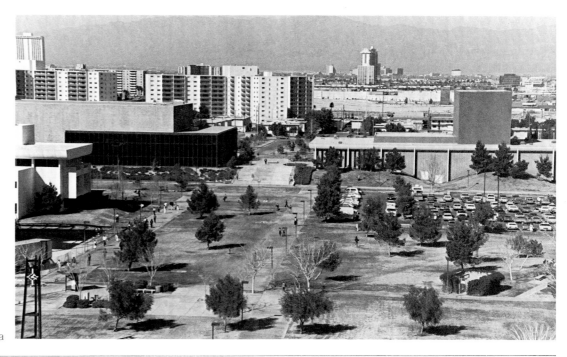

a

◀

Site
View of Las Vegas, looking northwest. The campus of the University of Nevada is in the center, the Strip is in the background and the Spring Mountain range is in the distance.

a
View of the University of Nevada looking north toward the Sheep Mountain range. The site is in the center between the Artemus W. Ham concert hall on the left and the Judy Bayley theater on the right.

On February 21, 1978, Oldenburg is notified in a letter from Brock Dixon, Acting President of the University of Nevada in Las Vegas, that "this University is interested in commissioning a sculpture. The project will be funded by a grant from the National Endowment for the Arts and a matching local grant. The total project including site preparation, installation and all associated costs is $70,000 The site for the sculpture cannot be modified. Both grants were conditioned upon a certain site which is a little plaza between the University theater and the University concert hall." The local donor is Robert Z. Hawkins of Reno, Nevada.

The artist was originally recommended in 1973 by an advisory committee composed of Dr. Henry Bruinsma of the Arizona State University, Henry Hopkins of the Fort Worth Art Center, Jan van der Marck of the University of Washington, Seattle, Gerald Nordland of the San Francisco Museum of Art, and the artist Peter Voulkos. The representative of the National Endowment for the Arts was Brian O'Doherty.

Oldenburg at first declines the commission. However, he soon has second thoughts and proposes a sculpture in the form of a ring, but Dixon replies that in the meantime the University has begun negotiations with another sculptor. On October 27, Dixon writes again: "...the negotiations in which we were engaged have gone off the rails." He renews the invitation: "We want you urgently to come out, inspect the site, and close the deal with us." After the artist visits Las Vegas November 13 and proposes a flashlight instead of the ring, contract negotiations begin.

The first version of a preliminary model is constructed by J. Robert Jennings to the artist's specifications and sent to the University, where it is approved May 25. However, fabrication is delayed because the concept presented in the model does not seem satisfactory to Oldenburg, who formulates a second version. A new model is built by Alfred Lippincott and presented at the University on January 25, 1980. This second version is accepted and the project announced in local newspapers. The site is studied and the sculpture's scale is determined. On April 23, 1980, the final plans are completed by J. Robert Jennings.

Costs of the sculpture are estimated as follows:

Engineering and models	$10,800.00
Materials	32,500.00
Labor	52,500.00
Lighting	10,000.00
Shipping	15,000.00
Installation	10,000.00
TOTAL	$130,800.00

Under the terms of the contract, the University will pay for the labor of installing the foundation but the artist must pay for the materials, estimated at an additional $1,500.00. These expenses do not include travel, photography, legal fees or compensation for the artist's time. It appears that the total project will eventually cost more than double the amount received. Under the contract, $45,000, which represents most of the payment, will be received only after the installation is completed.

FORMULATION OF THE FLASHLIGHT

Although the city of Las Vegas is best known for its flamboyant gambling district, the Strip, it can also be experienced as a sprawling city dominated by desert mountain formations. These extremes of artificiality and nature are everpresent. Even when one is standing on the site, a small plaza between the University concert hall and theater, the lights of the Strip and the outline of the mountains are both visible in the background, especially at nightfall. In his exploration of the site, Oldenburg searches for a stereotypical object whose form will reflect this coexistence of nature and man-made nature.

Light is the artist's primary association with Las Vegas. After having rejected the concept of a ring half-buried in the desert, whose stone would sparkle in the bright sunlight, the idea occurs to him of making some sort of beacon shining in the night. He remembers passing over Las Vegas on nighttime flights to Los Angeles, seeing the city as a small patch of light in a vast desert darkness. Playing around with scale, he identifies the beacon with a flashlight, a subject he is working on in a proposal for a building.

A flashlight between the two auditoriums seems to fit the situation since this object is commonly used by ushers to guide the audience to their seats. But a colossal **Flashlight** would also be dislocated from its own context, because the indoor, hand-held object has been enlarged and placed outdoors. This dislocation would be especially evident in the daytime.

The squat column formed by a typical flashlight would relate to the low scale of the surrounding buildings. Moreover, the form of the flashlight would mediate between the angular appearance of the concert hall and the curvilinear elements of the theater. At the same time the organization of elements in the stereotypical form of a flashlight would contrast with the architecture. For example, the protrusion of the switches identifies the object unmistakably as a flashlight, "spoiling" the effect of a classical column.

a

b
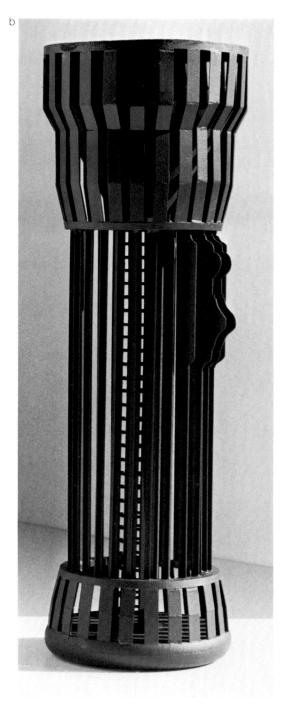

c
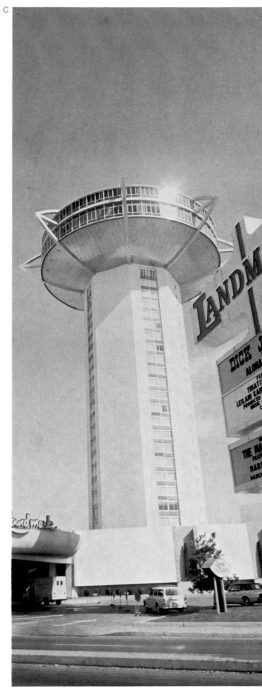

n the preliminary model, the **Flashlight** is eveloped into a sort of lighthouse throwing its eam upward. It has an open structure through vhich the wind and sand can blow, and contains spiral staircase for servicing the lights. -bars are made following the contour of the flashlight, expanding at the top in order to give an organic appearance, like a cactus in the desert. However, the outline becomes too angular and orizontal supports interrupt the vertical flow. Also, the light shining up into the sky to attract eople to performances seems melodramatic and liched, too closely resembling the light sculptures" on the Strip and searchlights used or store openings.

a
Elevation drawing by J. Robert Jennings of typical flashlight prototype, 1978 (detail).
Pencil, 92 x 61 cm.

b
Preliminary model of the Flashlight, first version, 1979.
Paper, wood, plastic, 42.5 cm. high.

c
The tower of the Landmark hotel in Las Vegas, one of the surrounding structures in the gambling district to which the first version of the **Flashlight** refers.

d
Postcard of the Dunes hotel sign on the Strip in Las Vegas.

e
The low scale of the campus architecture in relation to the mountains is shown in this idealized drawing.

f
The torch of the Statue of Liberty, here displayed to raise funds for the erection of the sculpture, is a clichéd symbol of "light held aloft." Another is the illuminated tower of the Empire State Building in New York City.

d

f
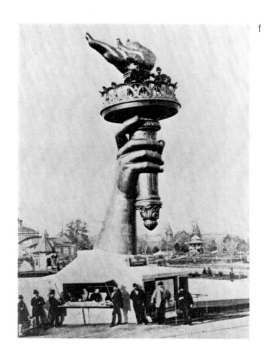

e
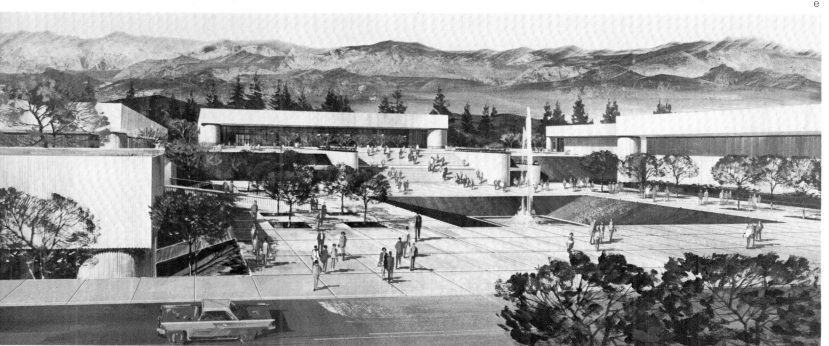

a

b

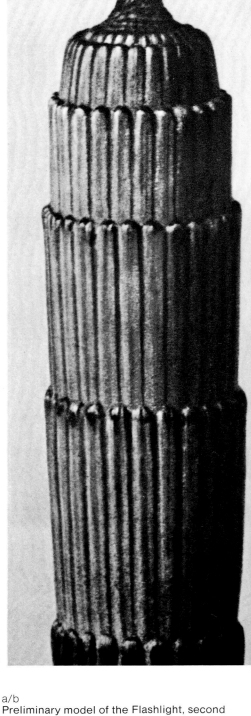

c

As a result the concept of the **Flashlight** is drastically reformulated and a second 'model is built. At Coosje's suggestion the **Flashlight** is turned upside down, making the light subdued, in opposition to the garish lighting of the Strip. Facing the light downward also provides the plaza with an intimate theatrical effect appropriate to its stage-like construction; wide stairs lead up to the plaza and the two auditoriums frame it like the wings of a stage.

The open structure is replaced by a central cylinder to which twenty-four uninterrupted profiles are welded. This form of construction makes a more organic outline possible. The flowing silhouette with the switches can now correspond to the outline of the desert mountains

at sunset, and the **Flashlight** column can be given a more plant-like appearance.

The opaqueness of the **Flashlight** increases the impression of intense blackness, which even during the daytime is maintained in the shadows between the profiles. On the other hand, the outer edges of the profiles will be pronounced due to the strong desert light. This contrast relates to the interchange and interpenetration of day and night in Las Vegas. The sculpture becomes a piece of the night extending into the day, an artificial effect which parallels the experience on the Strip.

a/b
Preliminary model of the Flashlight, second version, 1979.
Cardboard, wood, 71 cm. high.

c
The translation of the flashlight object is influenced by the images of timeless, monumental plant architecture photographed by Karl Blossfeldt in "Urformen der Kunst" (Berlin, 1935).

d
Flashlight profile, by J. Robert Jennings, 1980. Pencil, 46 x 114 cm.

e
View of Las Vegas against the silhouette of Frenchman's and Sunrise Mountains.

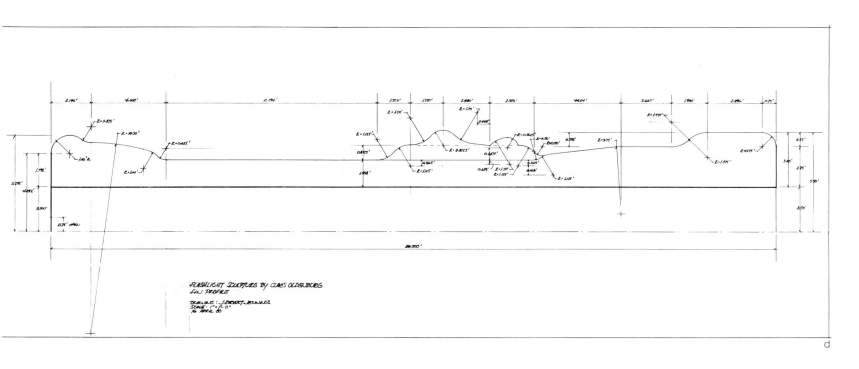

FLASHLIGHT SCULPTURE BY CLAES OLDENBURG
FIN PROFILE

DRAWING : J ALBERT JENNINGS
SCALE: 1" = 1'-0"
16 APRIL 80

d

e

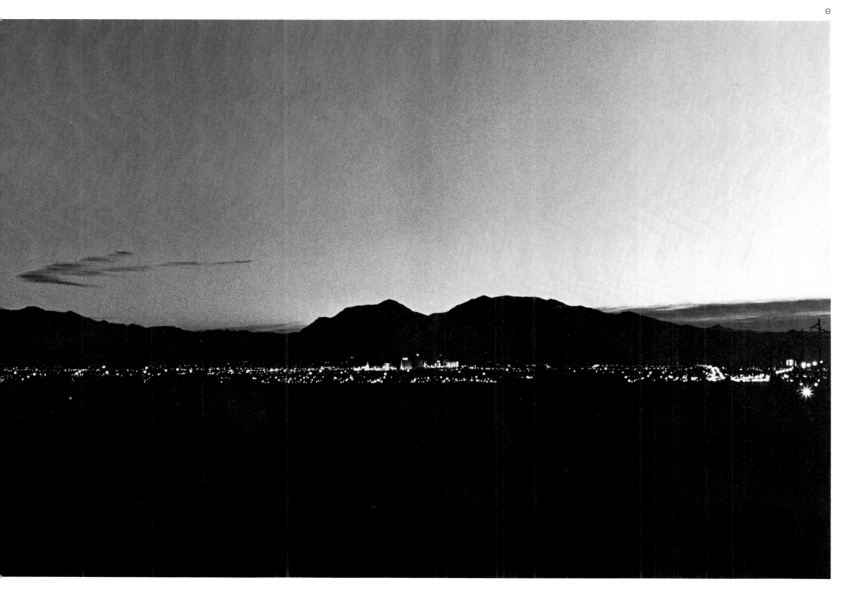

FABRICATION OF THE FLASHLIGHT

In its final formulation, the sculpture consists of a ½ in. thick cylinder 5 ft. in diameter, 38 ft. 6 in. high, to which twenty-four profiles of ¾ in. thick cor-ten steel are welded at 15-degree intervals. The profiles vary in width from 3 ft. to 1 ft. 4½ in. and are to have a "flame-cut" edge. About 18 in. below the bottom of the profile sections, under the floor of the plaza, the support cylinder will be welded to a base plate bolted to a foundation. The widest diameter of the **Flashlight** is 11 ft., the narrowest 7 ft. 10½ in. The sculpture will weigh 74,000 lbs. Twenty-four fluorescent lamps will be contained in a well 18 in. wide surrounding the bottom of the structure and covered with plastic sections. The paint used on the **Flashlight** must be as non-reflective as possible to give the deepest black.

The most critical technical problem is to avoid a warp in the long profiles. To minimize this possibility, steel that is especially flat has been ordered at extra cost from the steel mill. As the welds attaching the profiles to the cylinder will be exposed, special care must be taken to make them continuous.

The **Flashlight** is expected to be fabricated during the summer of 1980 and installed in September.

a
The Flashlight indicated on an elevation drawing by J. Robert Jennings, 1979 (detail).
Ink, pencil on photoprint. 28 x 56 cm.

The sculpture was tried at different heights in relation to the two buildings.

b
Flashlight, final plan by J. Robert Jennings, 1980.
Pencil, 127 x 91.5 cm.

c
Flashlight, final model, 1980.
Steel, aluminum, plastic, 94 cm. high.

An exact scale model of the sculpture which is followed in the fabrication of the work.

b

a

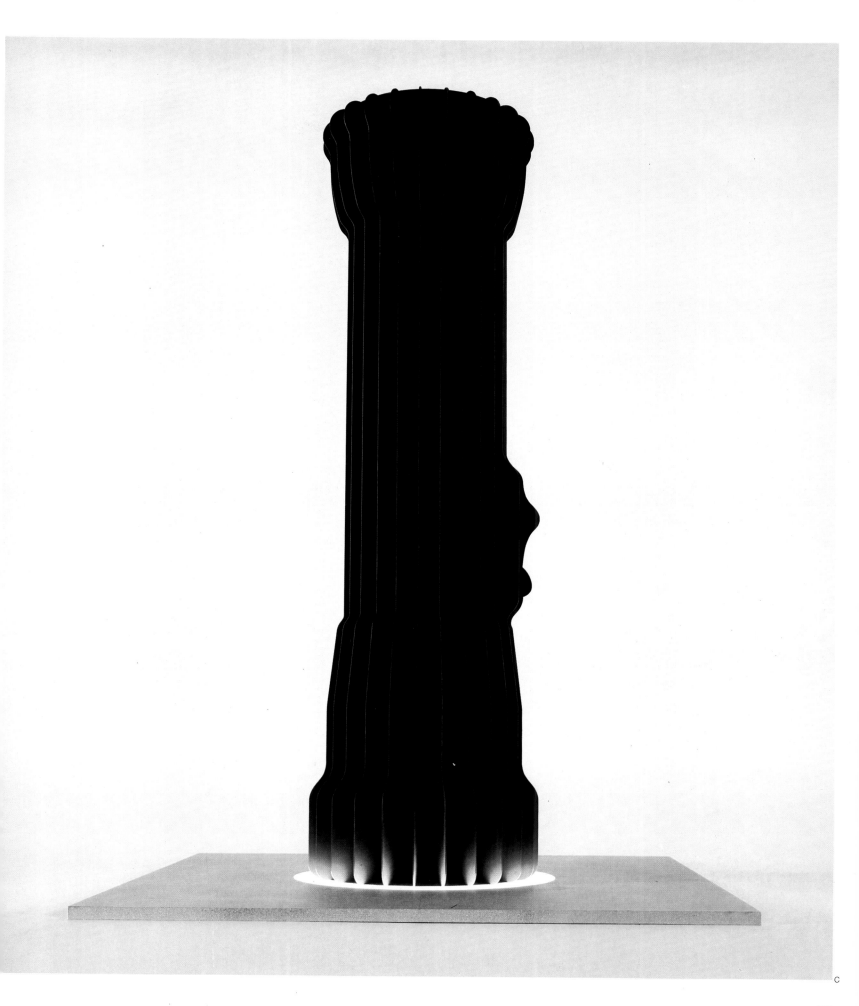

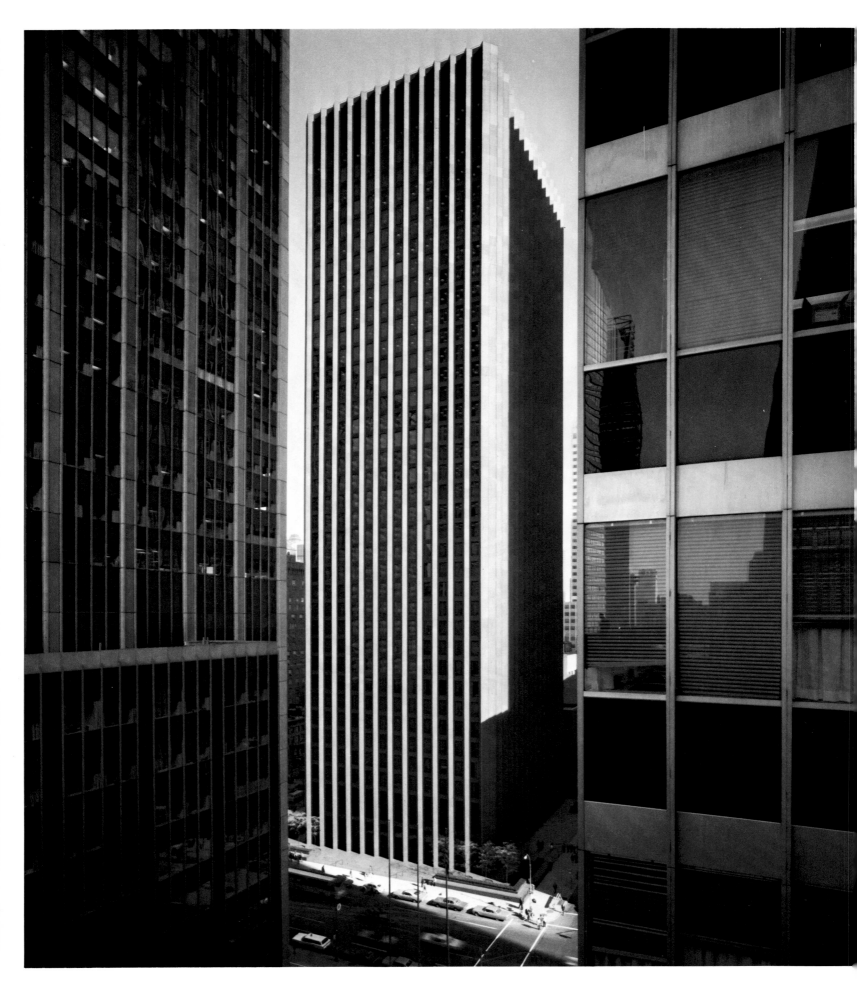

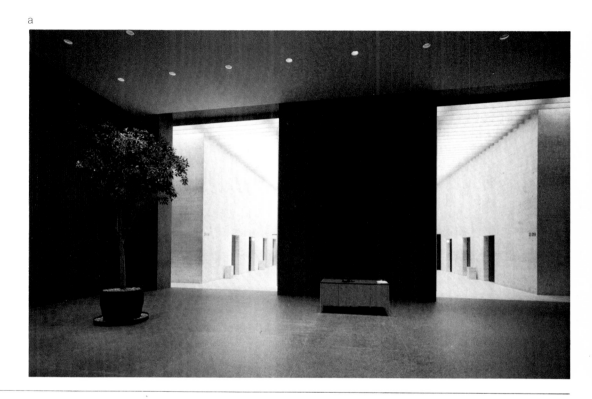

a

CBS building, between 52nd and 53rd Streets on
the east side of Sixth Avenue, completed in 1965
and designed by Eero Saarinen and Associates.

Saarinen's only high-rise building is a sheer,
freestanding 38-story concrete-framed tower
clad in dark grey honed granite; a somber
and striking understatement.

(AIA Guide to New York, New York, 1967)

Lobby seen from the entrance with a view of the
dark grey granite slab behind the security desk.

On March 23, 1978, Lou Dorfsman, Senior
Vice President of CBS and Creative Director
of Advertising and Design, informs Claes
Oldenburg that William S. Paley, Chairman of
the Board, has suggested commissioning him to
design a symbol for CBS in the form of a sculpture
to be placed on the granite slabs in the two
identical lobbies of the CBS headquarters building
between 52nd and 53rd Streets on the east side
of Sixth Avenue.

Oldenburg is not interested in designing a
corporate insignia but agrees to visit the site.
Looking at the lobbies he is struck immediately
by the possibility of a pair of giant switches as
both a symbol of the communications industry
and a form appropriate to the architectural
surroundings. He accepts the commission.

On May 23 a letter of agreement states the terms
under which the proposal is to be submitted.
Oldenburg will receive $5,000 from CBS for the
creation of a maquette. If CBS accepts the
proposal the maquette becomes their property,
and its costs will be deducted from the price of
the sculpture, estimated to be $100,000,
including materials and fabrication. If CBS
rejects the proposal the maquette remains the
property of the artist. The contract is approved by
CBS and plans of the lobbies are sent.

On May 27 Oldenburg finishes one half of the
maquette of the **Giant Switches,** before the project
is interrupted by a summer spent in Europe.
In the fall the maquette is completed and on
October 18 it is delivered to the offices of CBS.

On January 4, 1979, Paley states by phone that
he has seen the maquette, which he refers to as
a "drawing," but that he considers it too simple
an expression of the many activities of CBS. He
asks if another proposal can be made, but the
artist, not wanting to compromise his original
vision, declines, writing a letter in which he con-
veys his thoughts about the **Giant Switches.** The
maquette becomes Oldenburg's property in
accord with the agreement, and is returned to him.

A larger model in metal, with operational switches,
is made in February of 1980 in order to preserve
the concept.

FORMULATION OF THE GIANT SWITCHES

The **Giant Switches** are based on both the **Light Switches** sculpture of 1964-69, which hangs in Oldenburg's studio, and actual wall switches purchased on Canal Street. An early drawing for the project shows two switches side by side on the granite slab of the lobby, as in the sculpture. However, the scale of a single, larger switch seems a better solution in relation to the surroundings. As the switch has to be attached to rather than sunk into the slab, a container for the switch has to be devised. Single wall switches are purchased on Canal Street and studied, and cardboard models are made. The maquette of the two lobbies is divided in half and includes the passageways between them. The halves are placed back to back for the presentation of the maquette.

a
Light Switches, hard version, 1964/69.
Painted wood, 121 x 121 x 30 cm.

b
Study for the Giant Switches in the lobbies of the CBS building, 1978.
Pencil, 55 x 43 cm.

c/d
Broome Street studio views, June 1978, showing a cardboard study for the Giant Switches, wall switches purchased on Canal Street and the two parts of the Maquette of the Giant Switches in the lobbies of the CBS building, placed back to back.

e/f
Maquette of the Giant Switches in the lobbies of the CBS building (scale: ½ in. = 1 ft.), 1978.

The Giant Switches, if built, would have been made of bronze and measured approximately 1.7 m. x 61 cm., set in a base 3.4 x 1.5 m. The maximum projection of the switch from the wall would have been about 1.5 m.

g/h
CBS lobby seen from the entrance with a view of the dark grey granite slab behind the security desk. The passage is done in Travertine marble, the elevator doors are bronze. The lobby entrance at the other side of the building is identical.

a

b

c

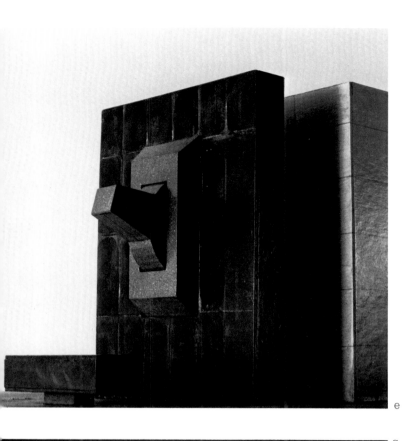
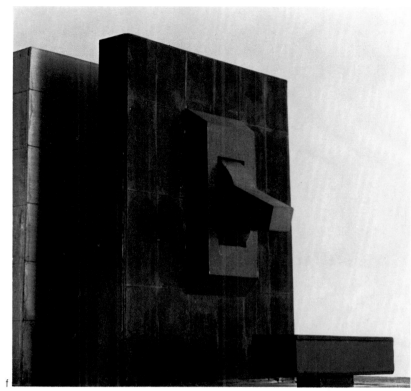

e f

g h

61

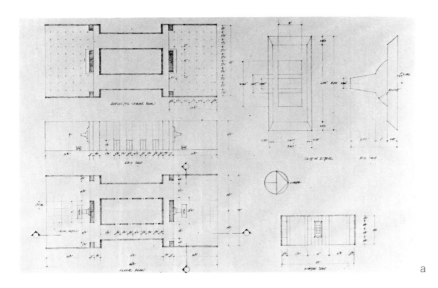

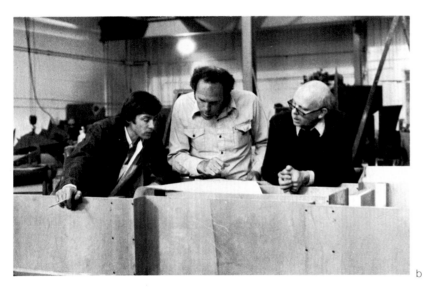

Letter written by Claes Oldenburg to William S. Paley on January 7, 1979, to explain his concept of the **Giant Switches**:

Perhaps the **Giant Switches** do not represent all the different activities of CBS. It may be difficult to find an emblem that does include them all. These activities are probably subject to change also, new ones being added, others dropping out. I took the concern of CBS in general to be "communication" and reduced this content, consistent with my approach, to its simplest common denominator—ON and OFF.

I think this proposal should be approached from the viewpoint of its effectiveness in the space of the site and the logic with which it meets the requirements: a sculpture in two identical parts at opposite locations. My solution allows the two parts to be the same yet capable of variation: one can be ON and the other OFF. I hope that Lou Dorfsman conveyed to you that the pieces are intended to be movable, which they are not in the model.

The **Giant Switches** are intended to be programmed in some way. They can, for example, rise with the day's activity to its high point and then lower—like a clock. Or they can stand ON during office hours and OFF at other times.

The lobbies of this monumental building do need something to bring them to life, something which fits within the visual and spatial situation. I ask you to imagine these **Giant Switches** made of bronze and in different positions, situated in the lobbies. Because in themselves they are architectural elements, having a form derived from ordinary light switches, they relate to the building and produce the effect of a second scale. The building is reduced in scale as the granite slabs on which the switches are fixed become transformed into part of the sculpture. Or the effect may be in the opposite direction—the details of the building become enlarged and the persons may seem even smaller in relation to it. Either way, the sculpture dislocates the existing scale.

The form of the **Giant Switches** relates not only to the Saarinen-CBS building but to the whole area of the city where this building stands, made up of huge monumental structures in simple form, with a million comings and goings, ons and offs— to project the simple action of the sculpture as a metaphor. The Saarinen-CBS building is certainly the best of those buildings and therefore should be the one that defines the climate of corporate monumentality in

the form of a work of art, thereby releasing some of the tension produced by the surroundings. The **Giant Switches** are intended to sum up in form and content the feeling of that part of New York coolly enough so that the statement can be observed over and over again, as it must be in a lobby situation. Everyone entering the building must recognize and appreciate the appropriateness of the **Giant Switches**.

a
Plan for the Model of the Giant Switches in the lobbies of the CBS building (scale: ¾ in. = 1 ft.) 1980, by J. Robert Jennings.
Pencil, 61 x 91 cm.

b
J. Robert Jennings, Don Lippincott and Claes Oldenburg during fabrication of the model of the Giant Switches.

c
Model of the Giant Switches in the lobbies of the CBS building (scale: ¾ in. = 1 ft.), 1980.
Aluminum, painted, with movable switches, 38.4 219.3 x 94 cm.

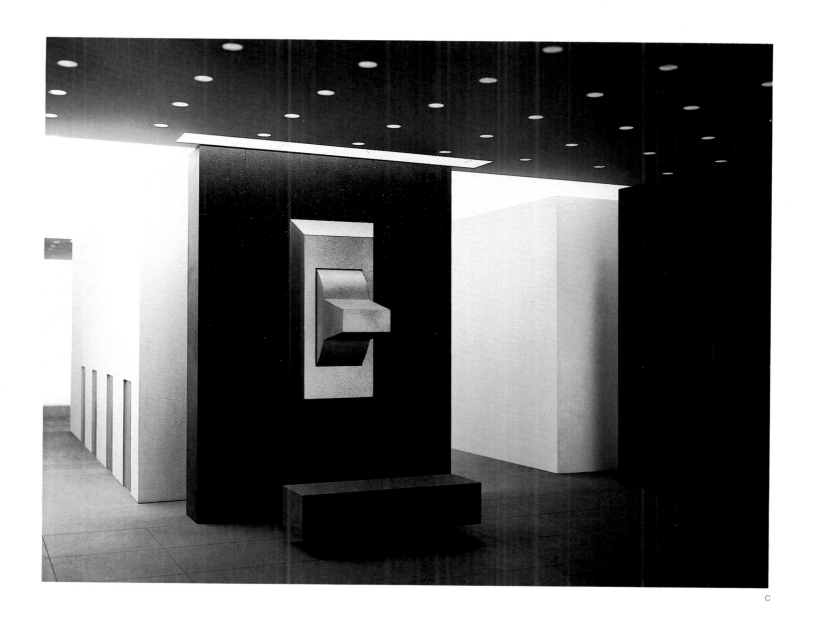

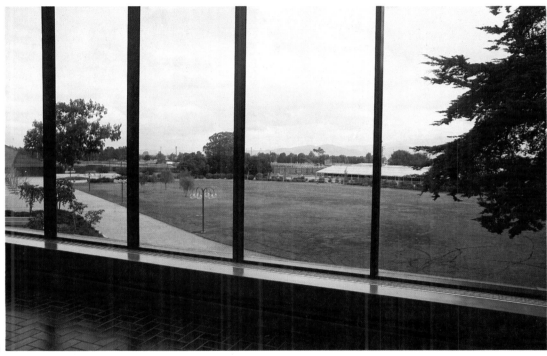

a

te
ew of the Salinas Community Center. The
ucalyptus trees and picnic areas are at the left and
e rodeo grounds are at the right. The sheds in
e lower center of the photo are stables.

he site seen from the galleria of the Community
enter building. The rodeo grandstand is at the left
nd the stables are at the right.

fter her first visit to Salinas, Coosje jots down:
omething blowing in the wind for Salinas. You
member Richard told us there's a lot of wind.
r something thrown. Or something floating. The
een field is too static, too inert. I think all the time
the signs on the field urging people to do
xercises." The grounds have a number of exercising
ations, each with a device and instructions on
w to use it. "Richard" is Richard Rhodes, one of
e architects of the Community Center building
nd a member of the sculpture committee.

On May 28, 1978, Theodore L. Thau,
Chairman of the Outdoor Sculpture
Advisory Committee of Salinas, California,
writes Oldenburg that he has been recommended
by consultants to the National Endowment for the
Arts to "create a large abstract sculptural work"
for the grounds of the Salinas Community Center.
The consultants are: Sebastian Adler of the
La Jolla Museum of Contemporary Art, Henry
Hopkins of the San Francisco Museum of Modern
Art and Dianne P. Vanderlip of Moore College of
Art, Philadelphia. However, the Jarvis tax-cut law
affecting municipal funding is about to be voted
on in California and Thau warns that the plans
may have to be drastically revised or even dropped
if the legislation is approved. The law, known as
"Proposition 13," is passed on June 6 and Oldenburg
departs shortly thereafter for Europe, assuming
that the commission has been cancelled. But Thau
writes on August 16 that this is not the case, and
proposes that money be raised "from the private
sector." Oldenburg is doubtful and soon
undertakes another commission, from Des Moines,
Iowa, which diverts his attention.

In the beginning of 1979 he is informed that "a
committee has been appointed, of bankers,
businessmen, ranchers and growers to find
money," and that the city of Salinas has pledged
to make up any deficit. Encouraged by this,
Oldenburg visits Salinas May 11, 1979, to study
the site and on July 15 accepts the commission.
An agreement is authorized October 29 by the
Salinas City Council and on November 26
Oldenburg receives an advance of $5,000 from
the local newspaper, toward the fabrication of a
preliminary model. On January 27 Oldenburg visits
the site again, this time with Coosje. On their
return to New York, the final stages of the
formulation take place. The preliminary model is
completed and on March 28 it is endorsed by the
sculpture committee. As a result, it is expected
that the matching grant money will be pledged
during the next few months. Meanwhile plans and
a precise model for fabrication purposes are being
prepared, together with an estimate of the
sculpture's cost.

FORMULATION OF THE HAT IN THREE STAGES OF LANDING

a

The Salinas site is unusually large, consisting of field 400 ft. long and 240 ft. wide in front of the Community Center building. It is surrounded by rodeo grounds, stables and picnic areas. One en is lined with tall Eucalyptus trees. This huge spa first appears advantageous to Oldenburg becaus it is so much in contrast with most sites he is offered, which are usually squeezed between buildings. But he soon realizes that a single sculpture could easily be swallowed up by the vastness of the space. One solution Coosje has i to extend the area affected by the sculpture by using an object shown in several stages of an action. This principle of extending an object in time and space has been developed by Oldenbu in drawings and models such as **Dropped cup of coffee**, 1967, **Paint can thrown against the wall**, 1969 (ill. p. 70) and three stages of a hat blowing along the sidewalk in 1974. The subject of the ha seems to fit since Salinas is a farming area and a hat is essential to anyone working long hours in the open air. The hat-in-action could tie together the two main areas of activity around the field: th rodeo grounds and stables at one end, and the Community Center buildings and picnic areas at the other. The concept decided on is that of a straw hat tossed out of the rodeo stands in three stages of landing on the field of the Community Center.

The seemingly casual positioning of the **Hat** deliberately ignores both the situation prepared for a sculpture in the plans of the Center and suggestions of a hierarchial location directly in front of the Community Center building.

The descending path of the **Hat** repeats the diagonal of the rodeo grandstand, and the saddle

b

66

rmed brims in a straight row recalls the
structure of the galleria, which the path nearly
parallels. The shapes of the brims relate to the
long, low metal roofs of the stables while the
crowns echo the rounded mountains beyond them.

The specific form of the straw hat is then defined
by Oldenburg. The object is reduced to simple
geometric components in order to give it a general
appearance and to adapt it to a fabrication
process. A prototype is built out of two discarded
objects found on the floor of the factory: a warped
grinding wheel and a plastic cup. The curve of the
brim is turned down instead of up, giving it the
shape of a saddle. The width of the brim is
established at 18 ft. The hat is to be made of ⅝ in.
thick aluminum, with a pattern of holes cut into it
to let through the sun and wind.

A tumbling or rolling sequence of the hat is tried
out but discarded. Instead a repetition of the same
position at different heights is used, giving an
effect of "landing," like a plane or a balloon. This
seems a better way to give the effect of a single
object seen at three moments in time.

The downward curve makes entrances to the hat
resting on the field. The hats above the ground
become "small pavilions" at different levels,
offering shade to persons using the open field.
The problem of how to support the two "floating"
hats is approached directly and practically using
two stilts for each hat, in the way that tall signs,
which are common in the western landscape, are
supported. The stilts will be engineered so that
the hats sway slightly in the diurnal winds which
are a constant of the Salinas climate.

a
Hat model, 1969.
Cardboard, painted, 14.5 x 25.5 x 31 cm., on
cardboard stand 34 cm. high. The stand for the hat
becomes part of the sculpture as in the Hat in
three stages of landing.

b
Straw hats are popular in Salinas and the Far West
clothing store offers a large variety.

c
View of the site. The Hat in three stages of landing
will be placed in a line roughly parallel to the back of
the rodeo grandstand, starting just left of center
in the photograph.

d
Preliminary model of the Hat, in three stages of
landing, 1980.
Plastic, paper, sand, metal, wood, 177.8 x 33.7 x
25.4 cm.

The stages will be located approximately 72 ft.
apart brim to brim so that the overall length of the
sculpture will be about 162 ft. The exact heights of
the floating stages have not yet been determined.

This preliminary model is an instance of the
presentation of a concept rather than a finished
design. The concept was accepted but the exact
details of the sculpture are still to be worked out.
Besides the heights of the "floating" stages, the
particular shape of the **Hat** crown and the pattern
of the perforations are yet to be determined.

c

d

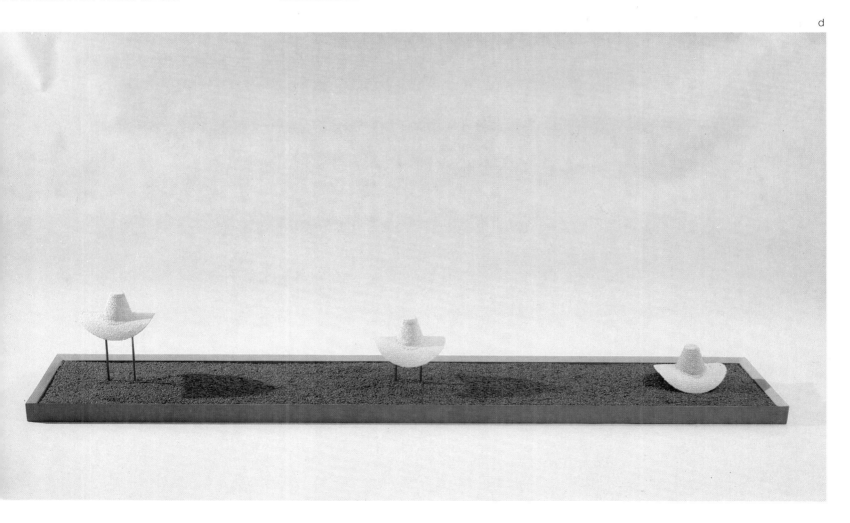

a

te
rial view of the Galleria complex in Houston,
xas, before the construction of the Marshall Field
d Company department store, designed by
hnson and Burgee.

odel of Marshall Field & Company department
ore, Houston, Texas, designed by Johnson
d Burgee.

The Marshall Field commission is first
mentioned in a phone discussion early in
June 1978 between Philip Johnson and
Claes Oldenburg about restoring one of the **Saw
Flags** owned by Johnson. A follow-up letter of
June 8 states: "What good news that you will
even look at our Marshall Field problems. I will
send you a sketch as soon as I have one." Johnson
writes further on June 15:

This wall is intended to be sheathed in
marble on the surfaces. The niches are to
be painted various colors. The low ones
will probably have trees planted. They will
peek through the niches. The top niches
would be above the height of the building
beyond and, therefore, any objects would
be silhouettes. We in no way need to fill
all the niches.

If anything here amuses you, remember we
can still change things around.

Plans and elevations received show a curved wall
twenty-one meters high and sixty-five meters long,
sheathed in Austin shellstone with a red granite
portal in the center, nineteen meters high, framing
an open area tiled in gold mosaic.

Oldenburg leaves for Europe before making up
his mind. On his return Johnson writes again on
September 13: "...Could we have ten minutes to
chat about it. There might be some possibility of
collaboration. After all, you are the granddaddy
of the 'store'...." He encloses a photo of a
maquette of the wall in which doll-house objects
have been placed in the niches.

On October 4 Philip Johnson, John Burgee,
Claes Oldenburg and Coosje van Bruggen meet
for lunch to discuss the façade for Marshall Field.
Remembering Johnson's statement that "we can
still change things around," Coosje proposes
removing the niches from the wall. Without the
niches, the artist is no longer forced into the
direction of filling a fixed pattern of holes with
objects, but can perceive the wall as an open,
undefined space. Johnson agrees to omit the
niches and has new elevations drawn up and sent
to Oldenburg.

On October 24 Oldenburg shows the first sketch
of paint thrown against the wall to Johnson and
Burgee, who support the concept. From then
until March 1979 the idea is developed from
models in the studio and a maquette executed
in painted aluminum at the Lippincott factory in
North Haven, Connecticut. Meanwhile, a pre-
liminary contract is signed on November 8 by
Oldenburg and Roger E. Glasson, Vice President
in charge of Real Estate for Marshall Field & Co.,
stating that $5,000 will be paid to the artist to
produce a model of his proposal for the north wall
of the store "together with recommendations as to
materials and full-scale dimensions for the
sculpture." If Marshall Field "should fail to approve
the design or fail to agree upon materials or
dimensions within 60 days after the presentation"
the model will be returned to the artist and become
his property. If the proposal is approved, the
model will belong to Marshall Field. Oldenburg
is to receive $50,000 for the concept and his
supervision of the project and Marshall Field
agrees to "bear the entire expense of materials

and labor required for such construction and
installation."

On March 19, 1979, at Philip Johnson's New York
office, the model is shown to Glasson and
A.R. Arena, president of Marshall Field & Co.
Johnson is enthusiastic and the project appears
to be favorably received by the two executives.
In the following days the cost of materials and
construction for the **Splats** is worked out in
conference with Don Lippincott and engineers
on the project in Houston. The element of time
is important as the store will open in November.
Because not all the **Splats** can be completed in
time for that deadline, Oldenburg suggests placing
them in stages, starting with a few that give the
direction of the whole and adding more every
few months. The final effect would be conveyed
by the maquette exhibited inside the store.

In a letter of April 24 summarizing production of
the **Splats,** Oldenburg states that "it is our feeling
that the sculpture can be executed and completely
fabricated at a cost of $150,000.00." He proposes
that the **Splats** be made of aluminum and painted;
promises to execute "one or more" trial **Splat(s)**
by June 1; and asks for a "go ahead within ten
days," saying, "this should enable us to complete
a substantial number of 'Paintsplats' by the end of
October 1979, which would allow the installation
of the first phase sometime early in November."
The ten days elapse and there is no response
to the letter.

Oldenburg reaches Glasson on the phone on
May 15. Glasson says that the proposal has been
turned down, and apologizes. A follow-up letter
makes the refusal official without giving any
reasons for it, saying only: "...We have decided
not to proceed.... In accord with our letter
agreement, the model and its design are of course
now your sole property and the agreement is
terminated."

On November 8, 1979, the façade is completed,
without niches and without sculptures.

a

b

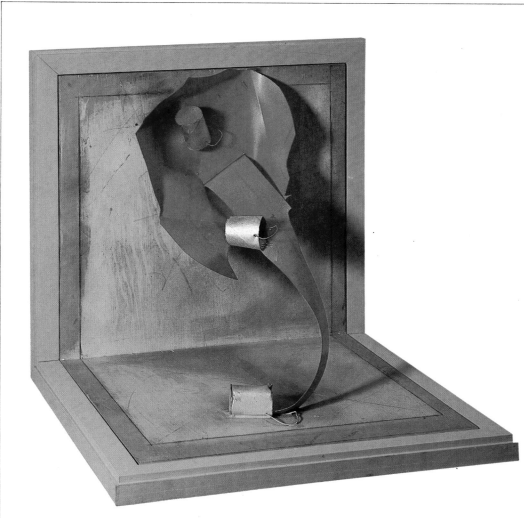

We were sitting in the Cafe Borgia II in SoHo after the Cunningham dance concert, having walked through the city on an exceptionally clear Sunday evening noticing the precise silhouettes. Johnson's façade was on our mind. The commission for Marshall Field had revived in me an old idea of combining my "Store" sculptures in some way with a contemporary store. Philip Johnson had suggested that I make objects to be placed in niches in the façade, but we agreed that this was not the right approach.

A few days before, Coosje had suggested to Philip Johnson and John Burgee that the niches be removed so that the wall could be used as a field, and they had agreed.

I said the idea must begin with the fact that we are dealing with a wall, and what can you do with a wall? On our way to the cafe I had noticed an appliqué sculpture on a building and remarked on signs, fire-escapes, things attached to walls, and spoken of a "billboard concept." This reminded us of the first manifestation of "The Store" at the Martha Jackson Gallery in 1961, which was a sort of three-dimensional mural effect, with the "Store" reliefs hung close together. Johnson's wall could be used in such a way, as a field for a brightly colored mural or a billboard, but it would have to be three-dimensional, like the Jackson "Store." Without repeating reliefs, in what way could the Store be referred to in a new concept? The bright enamel colors could be used. I still had cans of them in fact. But how? Coosje recalled the **Paint can thrown against the wall,** a proposal for a wall situation in the garden of the Museum of Modern Art in 1969, which exists only as a model. Yes, I agreed, you can throw things at a wall. What was needed was a statement counteracting the regimented vision of the architect. I favored a gestural application, perhaps strokes in different directions across the surface, eliminating the can. To apply the painterly "Store" approach seemed especially appropriate to this particular situation.

Another idea occurred to us of drips like water falling over a dam. Drips reminded Coosje of a clipping from 1965 of samples of fingernail polish in the form of drips and blobs on a field, which I had turned into a proposal to coat the islands of Jamaica Bay in New York with shiny surfaces of color. The true subject of "The Store" was paint and color. Drips and blobs could refer back to the subject, but in a fresh way, and seemed to go along with a current interest of mine in enlarging micro-details, such as salt and pepper grains.

a
View of mural with "Store" reliefs in the group exhibition "Environments, Situations, Spaces," Martha Jackson Gallery, New York, May 25 – June 13, 1961.

b
Model of a sculpture in the form of a thrown can of paint, 1969.
Painted cardboard on wood, 97 x 56 x 48 cm.

c
Notebook page: Can of paint thrown against Marshall Field wall, October 8, 1978.
Pencil, 7 x 12.7 cm.

d
Notebook page: "Things that can happen on/to a wall," October 8, 1978.
Pencil, 7 x 12.7 cm.

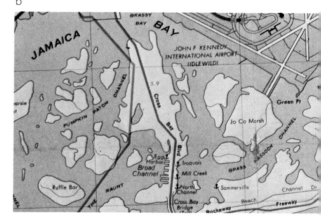

An idea developed that instead of a paint can thrown against the wall, the mural could be made up of three-dimensional paint specks, drips and blobs, or groups of blobs like the shiny-coated Jamaica Bay islands in New York. Another variation could be drips handled in a more calligraphic way. But in any case the shapes, we agreed, had to remain paint specks and not become a composition with biomorphic shapes in the manner of Arp or arabesques in the manner of Matisse or even drips in the manner of Pollock, but real paint traces. The huge blobs could be manufactured out of plastic or painted aluminum.

In the first formulation of the proposal submitted to Johnson and Burgee on October 24, 1978, the "Store" colors had been replaced by the colors of nail polish. I had been diverted by the strong association I had between cosmetics and a department store such as Marshall Field. The blobs were derived from enlargements of those in the original nail polish advertisement, joined in different ways. On the basis of this presentation the concept in general was approved.

Both architects seemed to appreciate the confrontation of art and architecture. However, soon thereafter Coosje and I began to feel that the nail polish forms were too bland and artificial, too anthropomorphic and without the necessary gestural movement. Instead, I started to study blobs by dropping and throwing the "Store" enamels onto blotting paper and letting them run, in order to achieve an organic effect and a relation between blobs. The clusters of **Splats** finally used were selected from several hundred of these. We returned to the idea of using the "Store"-type colors but decided to limit these to primary colors. In the final result, the paint seems to have been hurled up in three gestures: diagonally from left to right (red); diagonally from right to left (yellow); and vertically (blue). The effect caught in the image is of the paint beginning to run down the wall just after contact. The aluminum versions of the **Splats** are curved to intensify the effect of the shapes in space.

a
Notebook page no. 251A: Stains of nail polish, "Jamaica Bay," New York, 1965.
Ball-point pen, pencil, clipping, 28 x 21.6 cm.

A proposal to "beautify" the approach to Kennedy Airport by coloring the many little islands of Jamaica Bay.

b
Map of Jamaica Bay, New York

c
First proposal for Paintsplats (on a wall by P.J.), 1978.
Pencil, collage, watercolor, 68.5 x 184 cm.

d
Plan of placement of Paintsplats, April 3, 1979.
Photoprint, 154 x 222 cm.

e
Notebook page: Attachment of "drip" to Marshall Field wall, October 8, 1978.
Pencil, 7 x 12.7 cm.

c

d

e

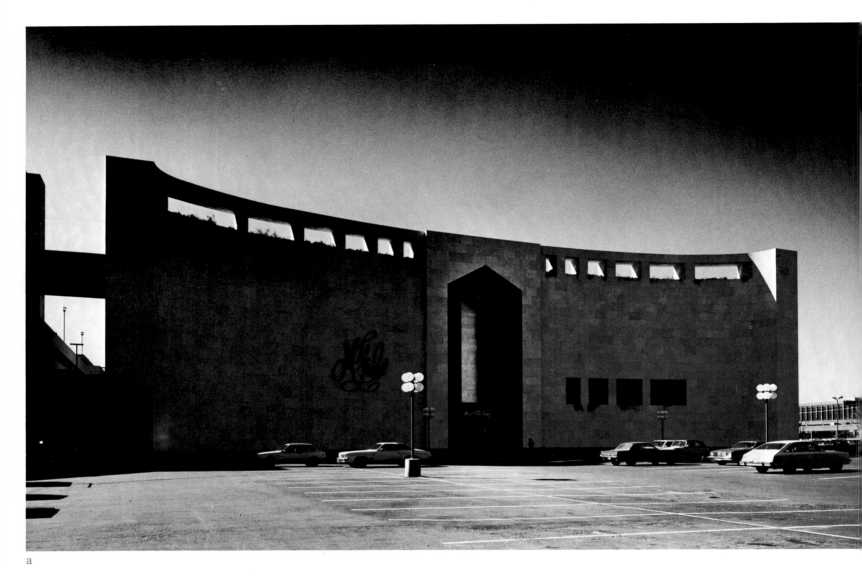

a

a
Marshall Field and Company store designed by
Johnson and Burgee in the Galleria complex,
Houston, Texas, completed November 8, 1979.

A 17-ft. logo of the store is placed like a giant
costume pin where a **Paintsplat** might have been.

b
Paintsplats (on a wall by P.J.)—model, 1979.
Painted aluminum, 68.5 x 227.5 x 53.2 cm.

The 96 **Paintsplats** — some single, some in clusters —
range in area from 0.2 sq. ft. to 310 sq. ft. They were
to have been executed in ½ in. thick aluminum. The
weight of the **Splats** on the right wall would have
been 18,850 lbs.; those on the left wall would have
weighed 17,140 lbs.

The model is built from a drawing by J. Robert
Jennings, adapted from the plan of the wall made
by the Johnson-Burgee firm. The scale of the
model is ⅜ in. = 1 ft.

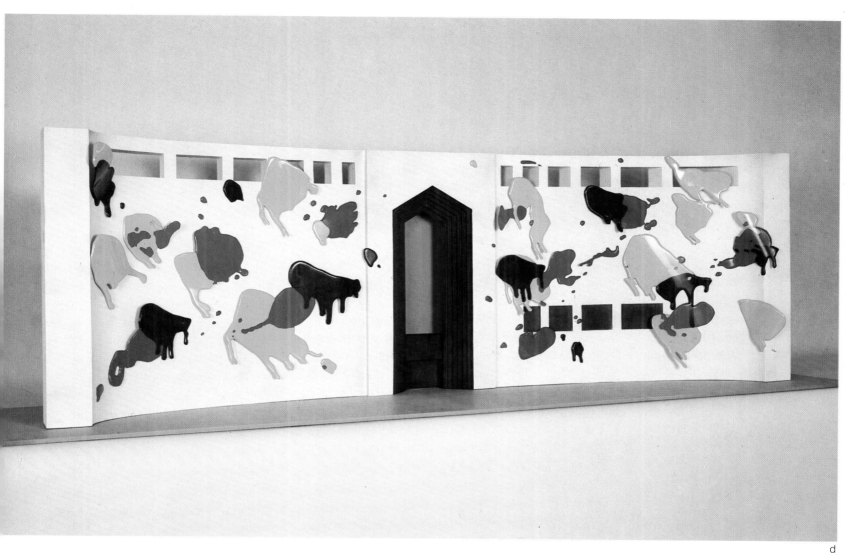

d

a

◀
Site
View of Des Moines from the Savery Hotel showing Locust Street leading up to the Capitol. The site is on the right in the foreground.

Conceived as the catalyst for the Capitol Center Development Area Urban Renewal Project, the Civic Center is on two downtown city blocks strategically located between the State Capitol and the Central Business District.

(Description from the application for a sculpture grant to the National Endowment for the Arts)

a
Northeast corner of the plaza chosen as the location for the sculpture.

In September 1978 Oldenburg is commissioned to make a sculpture for the new Civic Center of Greater Des Moines. The application for a grant to the Visual Arts Program of the National Endowment for the Arts by James O'Connell, manager of the Civic Center, states:

The Civic Center will provide a home for the area's major performing arts organizations.... The plaza will serve as a site for all manner of outdoor activities, including arts events and the Des Moines Farmer's Market...

The land, valued at $2.4 million, was donated by the City of Des Moines; $9.6 million for construction of the theater and plaza was raised by the independently incorporated Civic Center foundation from business, labor and individuals...

A major art work located on the plaza will be accessible to audiences for events in the theater and on the plaza; the office workers, shoppers, hotel guests and tourists using the plaza as the downtown's most convenient park; and to commuters using the major east-west arteries which bound the Center site...

The committee which recommended Oldenburg was composed of Jack Cowart of the St. Louis Art Museum, Lisa Lyons of the Walker Art Center and Jan Muhlert of the University of Iowa. The local committee consisted of James Demetrion, Director of the Des Moines Art Center, James W. Hubbell and Walter Walsh.

The grant is for $50,000, to which $75,000 is added from local sources. The total of $125,000 will cover all related expenses including costs of the foundation and the fabrication, transport and installation of the sculpture.

On October 13 he travels to Des Moines and studies the plaza in order to decide the location of the sculpture together with architects Charles Herbert and Scott E. Stouffer.

On November 21 a preliminary contract is signed, and an initial payment of $5,000 is received for the preparation of a model to be presented three months from the date of agreement. If the proposal is accepted the model becomes the property of the Civic Center.

From December 10 into January the **Crusoe Umbrella** is developed in a number of models, culminating in the final model in aluminum which is completed on January 31.

On March 13 the concept is "unanimously approved" by the Board of Trustees of the Civic Center, under the chairmanship of David Kruidenier. Planning of the sculpture begins at the Lippincott factory.

On May 29 to 31 Oldenburg visits Des Moines to decide the exact location of the foundation of the **Crusoe Umbrella.**

During June patterns are taken from the sections of the maquette and enlarged. In July all the large patterns are perfected and fabrication begins, continuing through October.

On October 31 the first assembly of the **Crusoe Umbrella** occurs in the yard at Lippincott, followed by adjustments and final approval on November 6. Meanwhile, negotiations on a final contract, begun August 15, conclude on November 12. Oldenburg agrees to pay $370 in additional costs for the foundation, and $1,900 extra for relocating three trees and removing a lamppost which stands in the way of the sculpture.

The completed **Crusoe Umbrella** leaves North Haven by truck for Des Moines in eleven pieces on November 15. It is installed November 27 and inaugurated by the mayor of Des Moines, Richard E. Olson, in a ceremony during the afternoon of November 29.

The final costs of the **Crusoe Umbrella**, exclusive of legal fees, travel costs and photography, are:

Materials	$30,100.00
Design and fabrication	38,100.00
Transportation	10,235.00
Installation	8,504.00
Foundation and removal of pole and trees	8,570.00
Painting of **Crusoe Umbrella** on site	1,000.00
TOTAL	$96,509.00

Oldenburg was not charged by Lippincott for the construction costs over the original estimate of $68,200, which came to approximately $52,000.

a

b

c

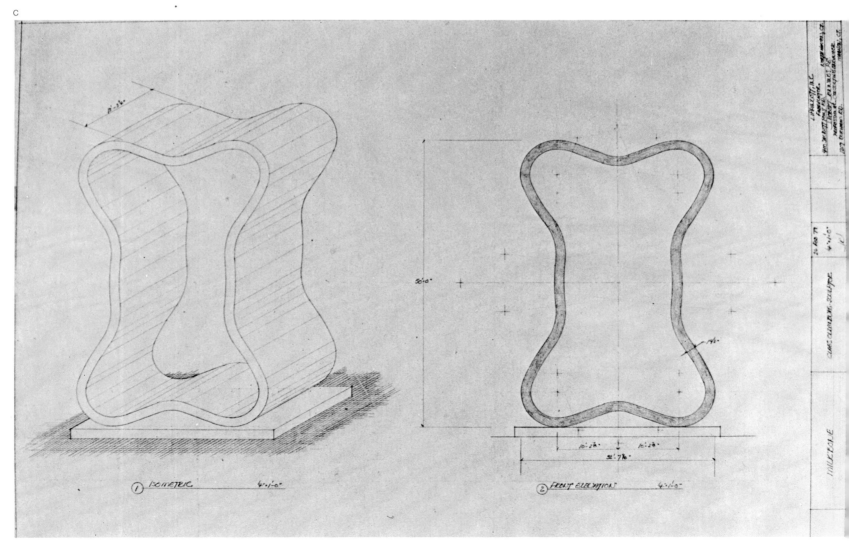

On October 13, 1978, Claes Oldenburg visits Des Moines to study the site and its surroundings. He explores the city-scape in search of a concentrated, evocative image which will include experiences shared with others and yet be individual enough to separate itself from the environment. Back in New York during October and November he develops his impressions into a number of proposals. One of these is a colossal loop in the outline of a "Milkbone" suggested by the "open, empty and airy" quality of the city space and by the Saturday night ritual of Des Moines' teenagers of circling the downtown area in their cars, called "scooping the loop." The Milkbone is to be poured in concrete in a horizontal position and then raised to form an arch. However, this project proves too elaborate and is abandoned. Other proposals, such as a campfire, a coil of hose and a bowling ball, all seem unsatisfactory.

a
Milkbones in different sizes, 1978.
Objects painted with enamel, on wood base, 14 x 20 x 5 cm.

b
The form of this metal cookie-cutter in the shape of a bear, similar in contour to the Milkbone, suggested the open treatment of the subject in the Milkbone Arch.

c
Plan of the Milkbone Arch or Loop, which was to be 50 ft. tall and 13 ft. 3¾ in. wide with sides 19½ in. thick. It was to be poured in concrete in a horizontal position, then raised upright on the Civic Center plaza.

d
Notebook page: Thanksgiving "campfire," November 1978.
Clipping. 28 x 21.6 cm.

e
Postcard purchased at the Des Moines airport, October 1978.

f
Notebook page: Donkey tail, pumpkin-stem and backhoes, "Iowa," 1979. Clippings, crayon, 28 x 21.6 cm.

d/e/f
Notes on the surroundings made during and after the first visit to Des Moines, which later influence the design of the Umbrella. For example, the stem of the pumpkin is related to the point of the Umbrella, and the backhoe structure is reflected in the shape of the Umbrella stem and the way it is broken up. The branches of the campfire recur in the models and the general appearance of the final Umbrella resembles the early windmill in the postcard.

d

e
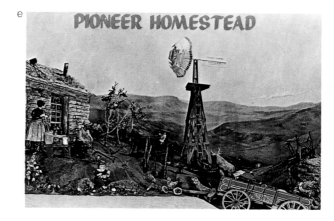

PIONEER HOMESTEAD

f

IOWA 2/79

a

b

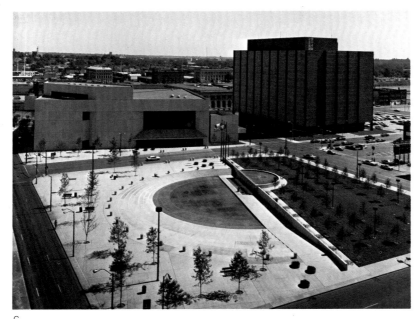

c

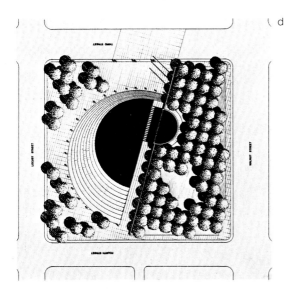

d

e

In early December Oldenburg reviews his impressions of the site with Coosje. The plaza was intended as an island in the midst of an urban situation, and so it is, though rather uninviting because of the rigidity of its plan and the excessive use of concrete. He recalls that he had a vision of being on a beach while standing on the empty plaza in October. This reminds Coosje of an image he is using for an etching, of a flowerlike parasol set on what appears to be a deserted island—a subject associated with Robinson Crusoe. This comparison is the origin of the proposal for an umbrella like that of Crusoe, which also looks like a parasol, serving as protection against sun as well as rain. The image is examined for its appropriateness to the site.

Near the plaza there happens to be a stereotypical profile of an umbrella on a sign advertising the Travelers Insurance Company. Oldenburg thinks of Wallace Stevens writing poetry while working at an insurance company. An umbrella like that of the etching will provide exoticism in the prosaic environment of the plaza just as recalling Stevens' poetry enhances the unimaginative Travelers Insurance sign.

The subject seems appropriate for other reasons. The shape of the **Crusoe Umbrella** relates to the plan of the plaza, whose rigid geometry, however, would be counteracted by the organic appearance of the umbrella. Its dome also relates to the domes of the Capitol building and the slope of Locust Street leading up to it. Yet the object stands out from its surroundings because of the paradoxical transplantation of a sea-image to the middle of the continent.

The reference to Defoe's lyrical account of practical everyday life both harmonizes with the utilitarian community of Des Moines and introduces the artist's long-standing identification with Robinson Crusoe. Just as the verisimilitude of Robinson Crusoe's accounts gives credibility to Defoe's imaginative world, likewise Oldenburg's practical method makes his fantasy likely in real surroundings. He proceeds from a poetic vision to the formulation of an object adaptable to fabrication procedures.

Isolating himself in his studio Oldenburg makes an umbrella, simulating the primitive circumstances under which Crusoe worked. After two or three attempts, he arrives at the final version, which seems to fit, in Defoe's words, "indifferently well":

> After this, I [Crusoe] spent a great deal of time and pains to make me an umbrella; I was indeed in great want of one . . . it was a most useful thing to me, as well for the rains as the heats. I took a world of pains at it, and was a great while before I could make anything likely to hold; nay, after I thought I had hit the way, I spoiled two or three before I made one to my mind: but at last I made one that answered indifferently well;

Oldenburg writes:

> Proposition: that I am Crusoe, playing Crusoe in my studio. Now I must make out of the materials at hand (on my studio/island) an umbrella against the elements, something I have never made before—with limited knowledge, limited tools and materials, but all the time in the world. Defoe's fictional description of the making of the umbrella is not very realistic, nor could Crusoe's umbrella have the fine manufactured look which Grandville gives it in his illustrations . . .
>
> No, this umbrella of Crusoe which has never

been seen and never will be seen must have looked much more like mine except that instead of the woods of South American trees I have the styrofoam of Canal Street, some years later...

The umbrella or parasol construction at least in the model which will be about the size of an actual umbrella should imitate the difficult methods Crusoe was forced to use and show the results of such difficulty.

a
A 19th-century illustration of Robinson Crusoe and his umbrella, by Grandville.

The curvature, knobbiness and segmentation of bone structure contribute to the approach in making the models of the **Crusoe Umbrella**.

b
Robinson Crusoe, 1955. Monoprint using sandpaper.

In this early drawing of the subject, one of a series of figures in a drawing style derived from plant forms, Crusoe is seen from behind. He wears a fringed hat and carries a simplified version of his umbrella in his left hand.

c
View of the plaza in the summer of 1978 showing the "deserted island" effect.

d
This plan was received with the first notice of the commission. It shows the organization of the site into a half-circle and a diagonal also found in the **Umbrella**. The severe geometrical effect seemed to require an organic form as counterbalance. However, despite its overall organic impression, the final design of the **Umbrella** includes straight lines and angles which relate it to the geometry of the Center building and plaza.

e
Northwest view of the site in May 1978 showing the Travelers Insurance Co. sign in the background.

f
Umbrella, inscribed "R. Crusoe," 1977. Crayon and watercolor, 28 x 35 cm.

The etching on which Oldenburg is working in the fall which figures in the choice of the **Umbrella** subject is based on this drawing made early in 1977. Although the umbrella form has been used by the artist before, the immediate inspiration for this version of the subject is the structure of the umbrellawort plant which he encountered in the garden of his father-in-law in the Netherlands. The sight of the bearded Dr. Koos van Bruggen tending his flowers and vegetables made Oldenburg think of Robinson Crusoe.

g
Preliminary model for the Crusoe Umbrella, 1978. Coated wire, 25 x 37 cm.

f

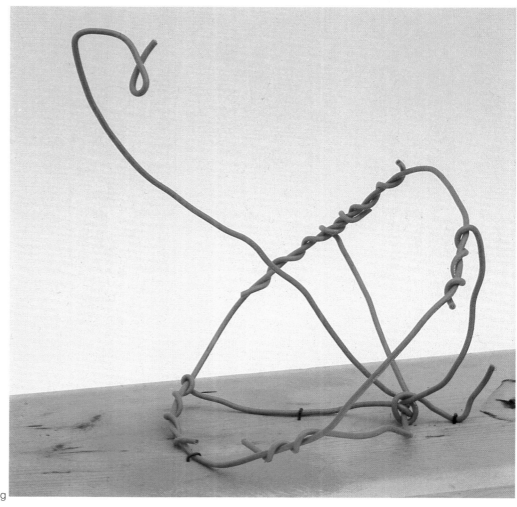

g

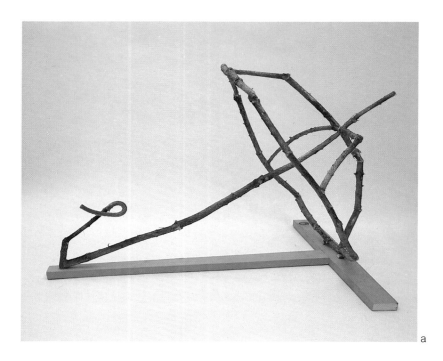

a b

c d

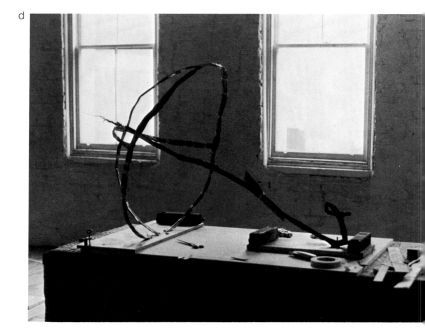

The first model for the **Crusoe Umbrella** made in December 1978 is very linear in construction, "like a line flung into space" (fig. g, p. 81). The umbrella is lying on its dome. Two more elaborate linear models in which the umbrella rests on both dome and handle follow, one of which is made from the family's Christmas tree (fig. a). After these, a flat bar-type construction of overlapping segments is tried in a sketch (fig. b) and rendered three-dimensionally in a model of cardboard taped to wire, first of the handle alone (fig. c) and then of the complete umbrella (fig. d). The dome in this model cannot support itself and has to be suspended from the ceiling. The cardboard model is later dismantled, except for the handle, and rebuilt in metal. Following this a construction of thicker, bone-like parts is tried in a styrofoam model and a section (fig. e and fig. f). In the styrofoam model the umbrella is again lying on its dome, but this position is finally abandoned

on the advice of the engineer. Dissatisfied with this approach the artist returns to the flat bar concept and produces a number of models cut in light cardboard, in which the domes are clipped from paper plates found in the studio and stapled together. One of these is chosen as the prototype (fig. g) and a larger version is made in a scale of ½ in. = 1 ft.

In this cardboard version the prototype is redone as a construction of individual overlapping segments, in a return to the earlier approach. The cardboard model is taken to Lippincott where it is translated into aluminum in a close collaboration between the artist and Robert Giza (fig. h). At this point all the aesthetic decisions must be made because this version of the **Crusoe Umbrella** will be the definitive model for the fabrication, except that the sections of the actual **Umbrella** will be about twice the thickness of those in the maquette.

Jennings uses the model for drawings which are sent to the architects in Des Moines and will later be used to indicate the foundations.

During the process of translating the **Crusoe Umbrella** model into the large-scale sculpture, Oldenburg records his thoughts:

> The solution to object sculpture in large scale is to open the object, remove mass but leave the essential and relate that to a logical, simple method of fabrication.

> The contour which is so important is altered slightly by being passed through several models, various scales, different tools, different materials and individual hands. I have cut it out several times in blade and scissors from different kinds of paper with drawings in pen and pencil in-between. Jennings has reduced it to straight lines,

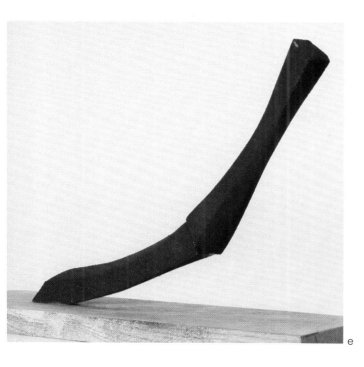

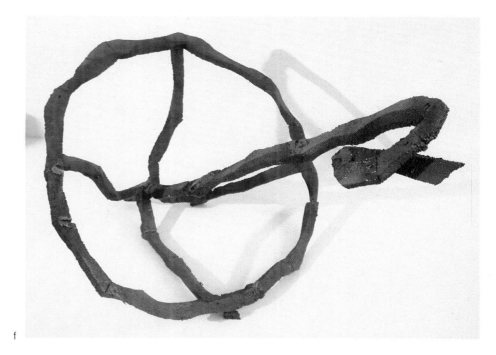

e f

g h

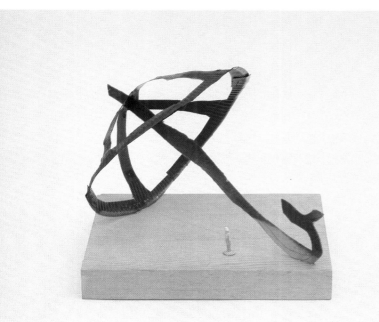

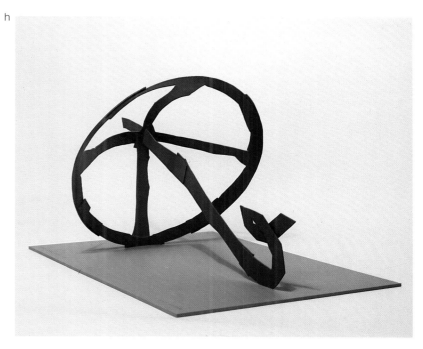

I have then softened his straight lines which then are traced onto steel and cut in steel, etc.

The concern throughout this work is to maintain an organic effect faithful to the sources of the image and its origin in drawing, while suiting it to the rigid procedures required by fabrication. Whereas in the **Batcolumn** the form develops from a concept in harmony with fabrication procedures, in the **Crusoe Umbrella** the natural, organic appearance is preserved despite mechanical necessities.

a
Preliminary model for the Crusoe Umbrella, 1979.
Wood, rope, glue, 52 x 56 x 86 cm. (on base 78 x 36 cm.)

b
Studies for the Stem of the Crusoe Umbrella, 1979.
Pencil, 28 x 21.6 cm.

c
Preliminary model for the handle of the Crusoe Umbrella, 1979.
Cardboard on wire, on wood base, 23 x 52 cm.

d
Preliminary model for the Crusoe Umbrella, 1979.
Cardboard on wire, spray enamel, 75 x 92 x 170 cm.

e
Preliminary model for two segments of the Crusoe Umbrella, 1979.
Foam, spray enamel, 20 x 26 cm. (on base 10 x 35 cm.)

f
Preliminary model for the Crusoe Umbrella, 1979.
Styrofoam, glue, spray enamel, 72 x 100 cm.

g
Preliminary model for the Crusoe Umbrella, 1979.
Paper, spray enamel on wood base, with figure in clay on nail, 15 x 26 x 21 cm.

h
Final model for the Crusoe Umbrella, 1979.
Aluminum, enamel, 42 x 72.3 cm.

FABRICATION OF THE CRUSOE UMBRELLA

Planning: Don Lippincott; structural engineering: J. Robert Jennings; execution: Edward and Robert Giza, Kymball Grant, Joseph Lesko, Salvatore Savo, Robert Stanford, Frank Viglione, Larry Wallace.

The **Crusoe Umbrella** has to be built from a three-dimensional model rather than a drawing. The dome is made of eight overlapping sections bolted together. The stem has two sections, one of which penetrates a plate at the center of the dome to which it is welded. The handle consists of several pieces welded together.

The problem is how to form these large, irregular sections and fit them together so that they correspond to the model of the **Umbrella.**

The first section to be built is the handle, which is detailed enough to indicate the effect that the

full-scale sculpture will have. In this section, for example, the ½ in. width of the bevelled edges is determined, and the fabrication method of the remaining pieces is defined.

Each section is hollow, consisting of two plates joined by an edge 5 in. wide. Both plates are first cut out of ½ in. thick, cor-ten steel, following outlines of paper patterns enlarged from the model and then curved and bent. Spacers are installed to keep the inner and outer plates at a consistent distance from each other. After both plates are placed adjustments are made so that the outlines correspond to each other and the curve of one

a

c

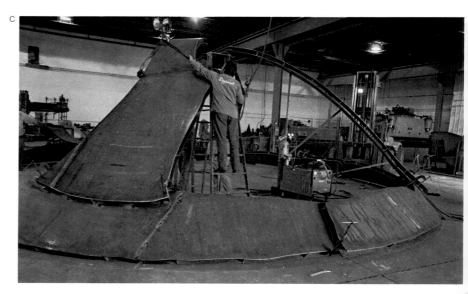

e

f

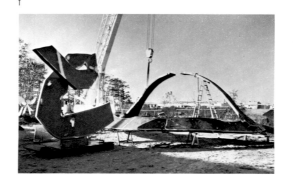

g

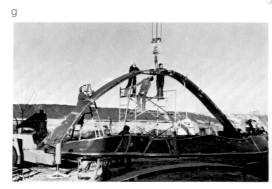

ction in the overlap matches the curve of the ...er. The irregularity of the profile requires that ...e edges be attached in many pieces, some of ...ich must be formed in the roller.

...ter completion of all the sections, the **Crusoe** ...nbrella has to be erected outdoors in order to ...ow how the components fit together. Once the ...eces of the dome are temporarily clamped and ...elded together, it is raised and held by one crane. ...ext the stem is raised by another crane and ...serted through an opening in the center plate ...the dome. When the angle of the stem in relation ...the dome has been determined by comparison with the maquette, the stem is welded to the dome and bolted at the other end to the handle. The position of the base plate which will anchor the dome to the plaza is now fixed, after which the **Crusoe Umbrella** is taken apart again for sandblasting, finishing and painting.

a
Defining the enlarged patterns of the dome, July 1979.

b
Fitting the stem to the handle, July 1979.

c
Setting the dome sections into position with C-clamps, September 1979.

d
Finishing the edge sections of the dome, October 1979.

e through j
Stages in the assembly of the **Crusoe Umbrella** in the factory yard, October 31, 1979.

b
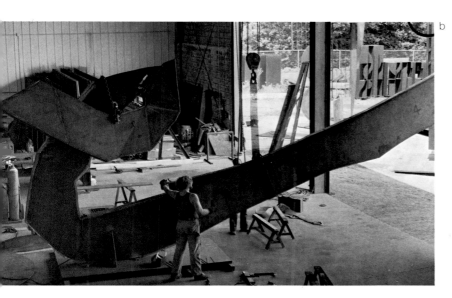

d
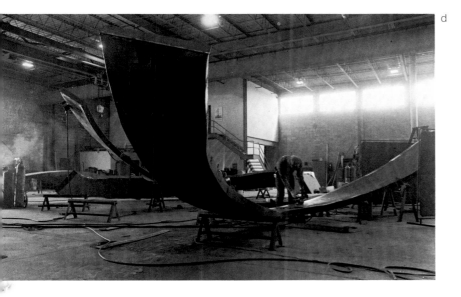

i
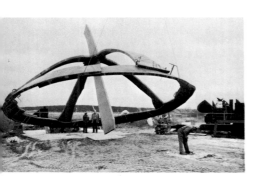

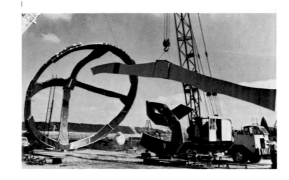

j
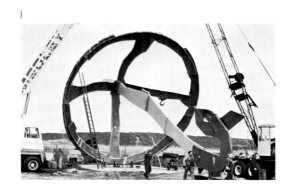

INSTALLATION
OF THE
CRUSOE UMBRELLA

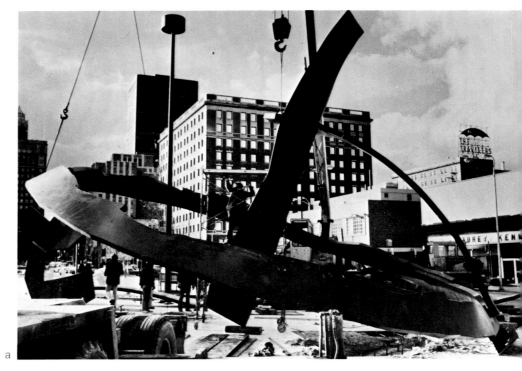

a

a through d
Installation of the **Crusoe Umbrella**, the Civic
Center plaza in Des Moines, November 27, 1979.

b

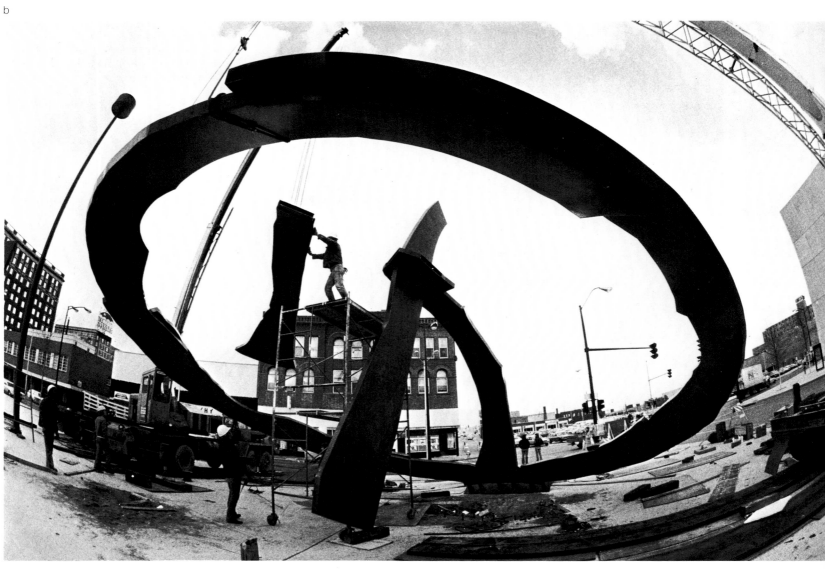

c

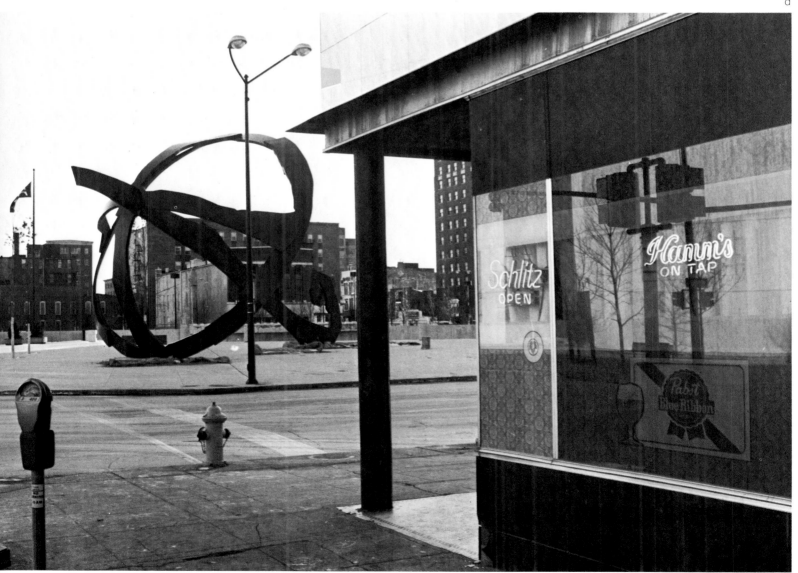

d

a
The **Crusoe Umbrella** viewed against the entrance
to the Civic Center.

b
The **Crusoe Umbrella** seen from the Civic Center.

The Crusoe Umbrella weighs twenty tons and is 57
feet long and 33 feet high (17.4 x 10 m.). The color
is a deep blue-green, chosen for the contrast it makes
with the more yellow-green of the foliage in the
surroundings.

a

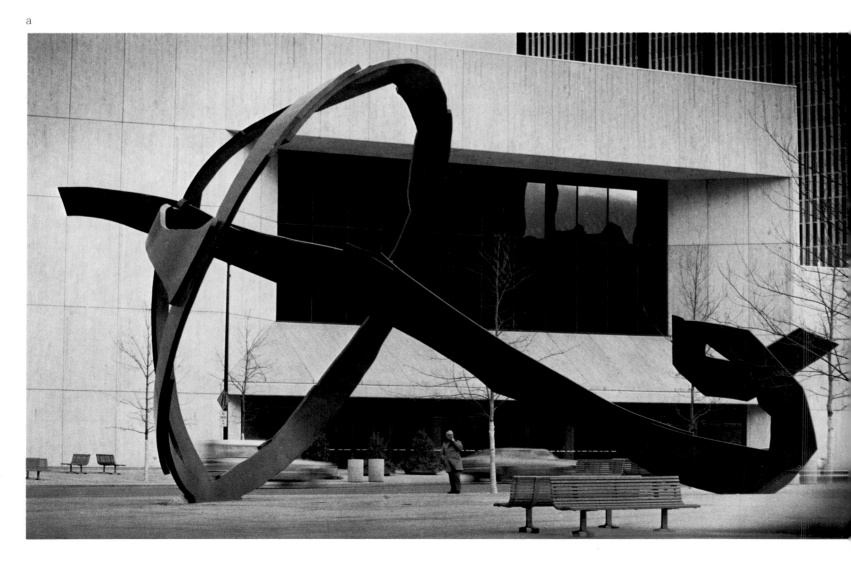

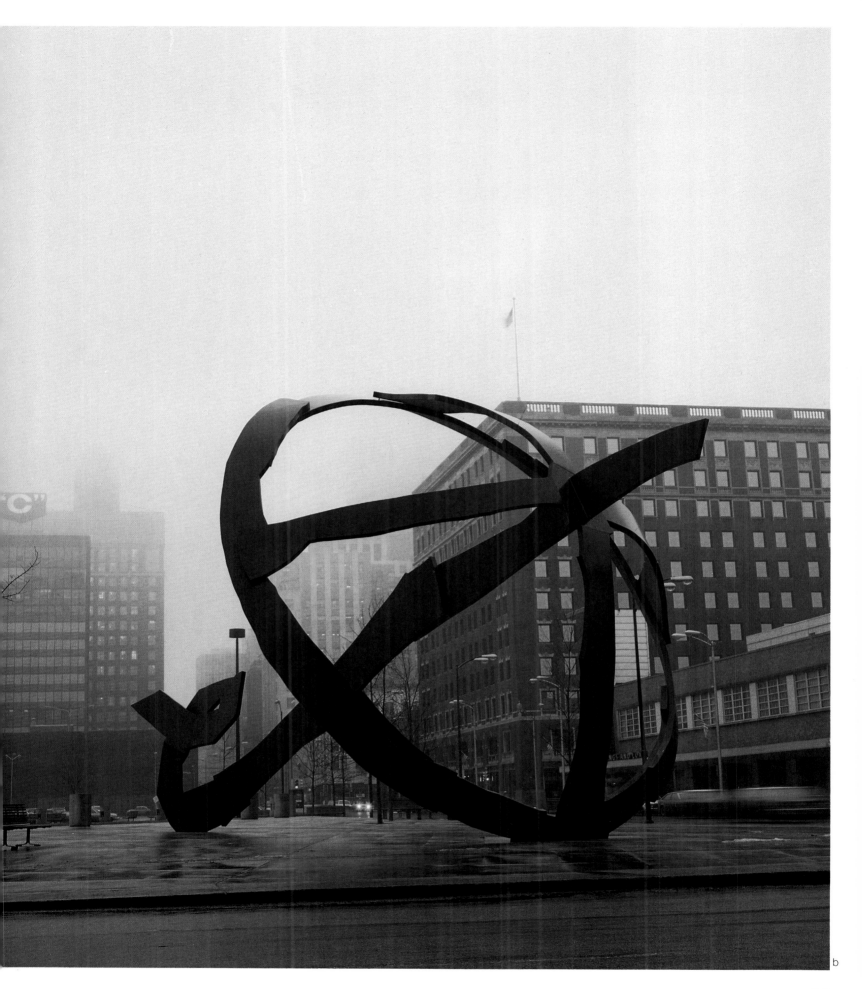

THE CRUSOE UMBRELLA & FLASHLIGHT RECONSTRUCTED WITHIN THE LEO CASTELLI GALLERY FROM MAY 24 TO JUNE 14, 1980.

c

Sites

View of the interior of the Leo Gastelli Gallery
142 Greene Street, New York City.

The height of the gallery is 18 ft. (5.5 m.)

b/c
Views of the interior of the Leo Castelli Gallery
t 420 West Broadway, New York City.

The height of the gallery is 10 ft. 4 in. (3.1 m.)

During the period from 1977 to 1980 Claes Oldenburg has been primarily concerned with public sculpture projects for specific urban sites in various cities of the United States and Europe.

Drawings, three-dimensional sketches and models related to these projects can be shown in a gallery situation for their intrinsic formal qualities and the insight they provide into the artist's working method. However, the final works no longer fit in this context, and not for reasons of scale alone. When the public sculptures are disconnected from the particular city-scape in which they function and from which they are derived, they lose their character as modern icons to become arbitrary objects.

As an alternative, the Leo Castelli Gallery spaces are used as sites for full-scale models of two public sculptures, in order to indicate their actual size and to show how they have literally outgrown the gallery situation:

A full-scale model in balsawood of the 56 ft. 8 in. (17.3 m.) long and 33 ft. 4 in. (10.2 m) high steel **Crusoe Umbrella** on the Civic Center plaza in Des Moines is built as though intersected by the walls and ceiling of the gallery at 420 West Broadway.

A full-scale model in plywood and aluminum of the 38 ft. 6 in. (11.7 m.) high steel **Flashlight** for the University of Nevada in Las Vegas is built as though intersected by the wall and ceiling of the gallery at 142 Greene Street.

The fabrication of **The Crusoe Umbrella intersected by the Leo Castelli Gallery at 420 West Broadway, New York City** takes place in the back yard of Douglas Caulk's home in Nanuet, New York, April to May 1980. The **Umbrella** section is built by Caulk with the assistance of Randy Dalton, Rollie Erickson, Michael Prudhom and Steve Vercelletto. Lengths of balsawood are laminated together to form the sections of the **Umbrella.** The crew works from the model of the Leo Castelli Gallery installation and from plans used in the fabrication of the steel **Umbrella.** Michael Reed visits Des Moines to take additional measurements of the sculpture.

The **Flashlight intersected by the Leo Castelli Gallery at 142 Greene Street, New York City** is built by Douglas Caulk and Alan Steele with the assistance of Marybeth Welch.

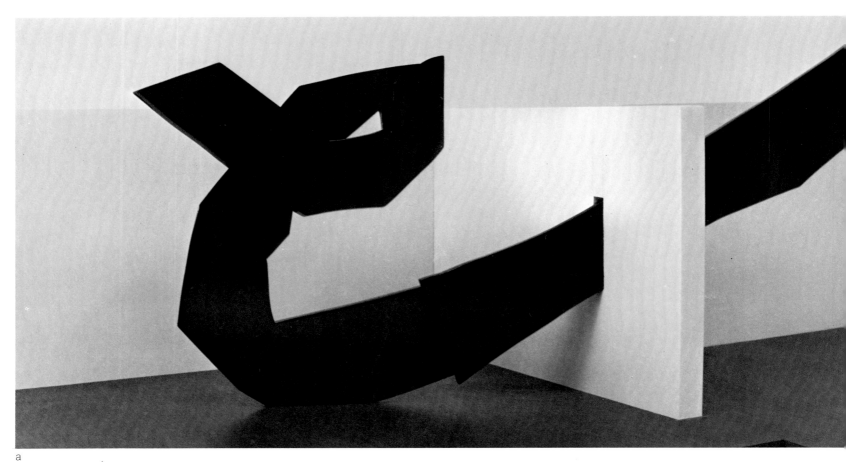

a

b

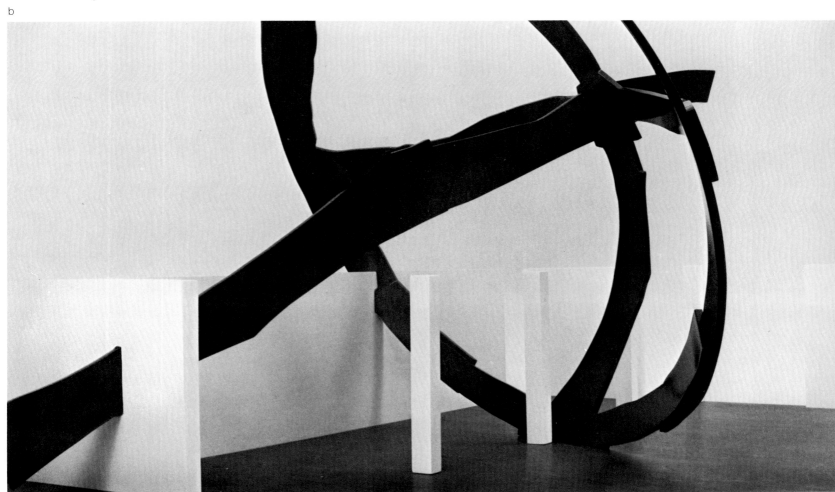

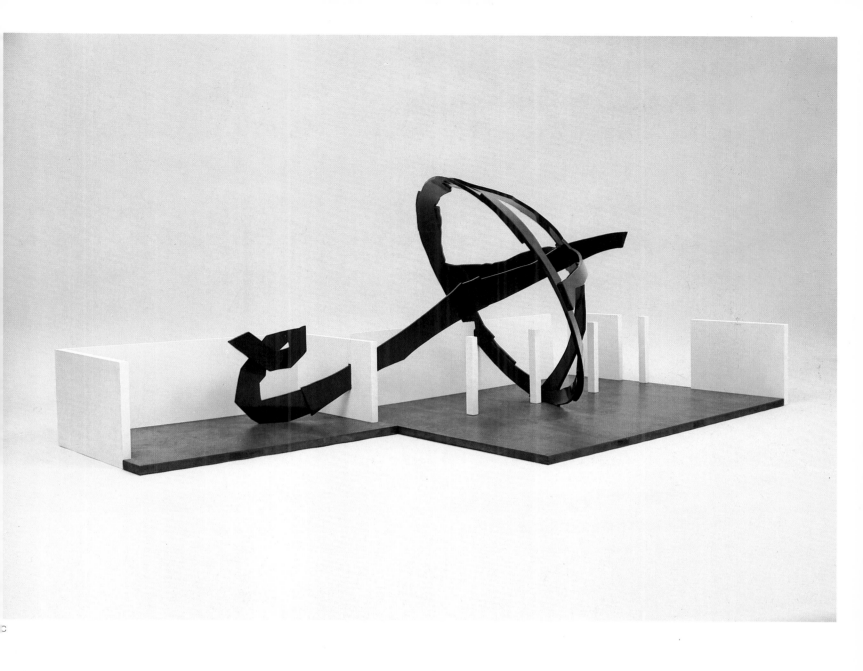

a/b/c
Model of the Crusoe Umbrella in the Leo Castelli
Gallery at 420 West Broadway, New York City, 1980.
Aluminum, wood, 62.3 x 159 x 85.9 cm.

The model is constructed in a scale of ¾ in. = 1 ft.
The **Umbrella** model is made by Robert Giza; the
model of the gallery is built by Douglas Caulk,
Michael Reed and James Vitto.

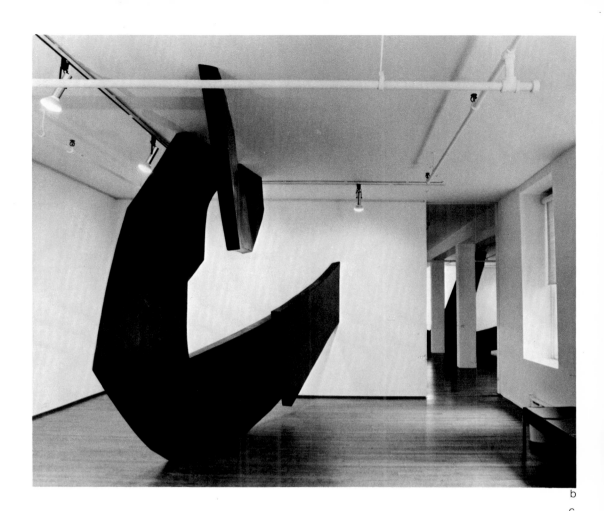

The Flashlight intersected by the Leo Castelli
Gallery at 142 Greene Street, New York City, 1980.
Plywood, metal, painted.

b/c
The Crusoe Umbrella intersected by the Leo
Castelli Gallery at 420 West Broadway, New York
City, 1980.
Balsawood, painted.

b

c

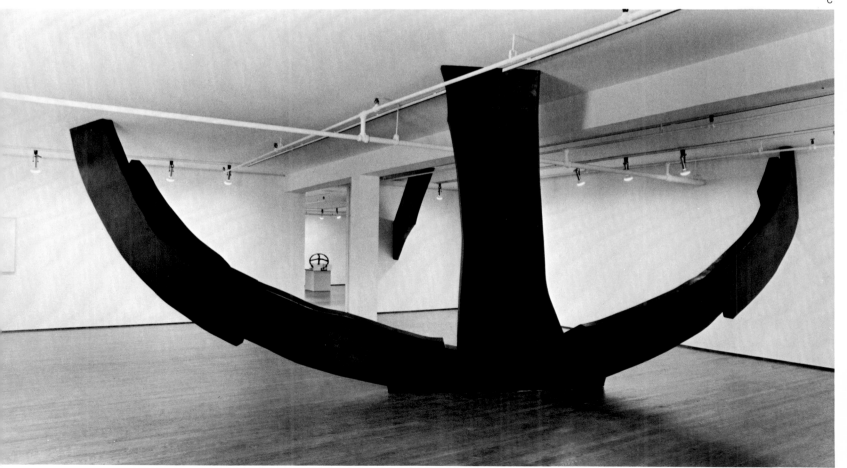

MONUMENTS

1 The world is full of monuments. Throughout history the State and its ruling class, in its historical pride, have taken care that posterity as well as their present subjects should never forget them and their achievements. The form of these monuments has fluctuated with sculptural style. The objective of those who commissioned monuments was, however, always the same: the historical and moralistic message should be loud and clear. Certain sculptural styles could satisfy that purpose better than others. Most historical monuments we see around us are designed in a version of Renaissance Classicism. They consist of an architectural support structure, ranging from a simple pedestal or column to colossal edifices like the **Arc de Triomphe** in Paris, crowned and encrusted with life-size (or larger) statues.

In Renaissance Italy, where these forms originated, they were developed in emulation of classical Rome. The Renaissance had the curious view of Rome as a city with two levels: a proud people walking the noble streets and squares, and above those the people of stone and bronze on columns and arches or fitted into the façades of public buildings: its gods, its rulers, its heroes, visible from below as one looks up in reverence, inspiring and ennobling the present. This conception informed and shaped Renaissance sculpture, which was meant to be monumental. Thus, while the objective coincided completely with the formal principles of style, the Renaissance monuments were made by the best sculptors. The monument then was not only an object of historical pride but also one of artistic pride. It was logical to erect it in a prominent place where it could be seen clearly and from some distance. Intersections of streets were widened to accommodate monuments, which were designed to command space just as the historical grandeur implied and projected by their presence was meant to command the minds of the people below at ground level. In many instances the location of monuments became a force in the urbanistic planning in classicistic cities like Paris, Berlin or Washington, D.C.

As the vogue for ever grander monuments continued, a direct reflection of growing nationalist absolutism, they became steadily less inspired as works of art. They became dogmatic in themselves: dogmatic formally and dogmatic iconographically. A monument was a monument: too serious for free artistic experiment. Monuments of imperial domination had exactly the same architectural and sculptural form as monuments of liberation. The human figure whether a portrait or an allegory, was always the prime vehicle. Thus the final death of the monument came when the human figure lost its importance in serious sculpture. Auguste Rodin's famous design for a monument to Balzac was rejected out of hand. He could have expected it; it simply was not a monument. This magnificent and aggressive shape of bronze is, as art, speculative and exploring. The society of letters which commissioned it could not tolerate letting a wild sculptor, whose objective was art, violate the sacred memory of the great writer. The monument should not shock; the monument should pleasingly evoke, not discuss. It should be dead art.

2 The classical monument is the sign of glorious completion. It is erected after the event: as a moralistic, idealistic memorial. The monument diverts attention from the present to the past. The knowledge of past achievement then returns to the present as a **shaped** memory—enlarged and exalted in symbolic stone and bronze. The essential medium of articulation in this cycle is scale. Scale is relative to the nature of the site. The classical monument's favorite site, in the center of a square or at the end of a long avenue or in front of a public building, was always carefully chosen or constructed. The site is a focal point. It situates the monument in a civic and urban decor. At the same time it separates the monument from its surroundings, setting it apart in its lofty grandeur. The site is a theatrical space: it displays the monuments. Through its lay-out of roads approaching and encircling the monument, the site organizes and shapes perception. The best monuments, such as the **Arc de Triomphe** in Paris, one sees already from very far away. It takes a long time to reach it. As one approaches it, it is always there on the horizon, hardly coming closer. Its presence becomes oppressive. This makes the monument into a dramatic object: a precisely orchestrated display of historical past as timeless value. (Its audience is the nation.)

3 Rodin's **Balzac**, which was an artist's idiosyncratic attempt to create a monument as sculpture, signifies the ultimate and inescapable disassociation of art and the monument. Since a monument was erected to render an achievement timeless, its form could not, of course, reveal the traces of personal style. Monuments should have no style; thus they continued to be made in the style that could be considered to have survived longest (while at the same time being eminently suited to high rhetoric): antiquarian classicism—in the sober formulation of its nineteenth-century masters, Canova and Thorvaldsen. Modernist sculpture, with its nervous search for formal and structural variation and innovation in an area in which normative principles were no longer in operation, was no match for classicism. Occasionally those classicist monuments are still being made. They have nothing to do with art; they are an insult to Donatello, Michelangelo, Bernini and even to Chalgrin, the master of the **Arc de Triomphe**. The task of providing the world with fashionable, modernistic versions of the classical monument, has passed to architects and designers. They employ the classical vocabulary in an abstracted form. Meaning is provided by elegant inscriptions. Art is no problem.

4 A truly great monument is never just an absolutist gesture by a ruling class towards its subjects. It also reflects how a people or a community wishes to see itself—a collective dream of national fulfillment and honour. When the **Arc de Triomphe** was designed and its construction started, in 1809, it was not only Napoleon who thought himself superior. The French people too were convinced that they had made the world an incalculable gift: Liberté, Egalité, Fraternité, now after the turmoil of revolution informing a new order under equal law. And many people outside France, especially in Germany, saw Napoleon as the perpetrator of the ideas of the Revolution—liberating them from the rule of autocratic princelings under antiquated laws. All this, the sense of a new world, is signified too by the **Arc de Triomphe**. And another, maybe the most beautiful monument ever made, Donatello's equestrian statue of the **Gattamelata**, perfectly sited in front of Sant' Antonio in Padua, quietly looking towards the city center, no doubt exemplifies notions of civic pride and dedication to duty which were wide-spread Renaissance ideals. So the great monument is, instead of a cold recollection of the past, an intersection of art and (contemporary) life which is, in T.S. Eliot's phrase, the living moment of the past. The product of this marriage is an icon which collects meaning instead of projecting it. At this level lies the achievement of Claes Oldenburg's monuments.

5 Of Oldenburg's monuments one critic has remarked that they are "a metaphor for scale." I do not object to that observation though it covers only a small part of their quality. These monuments are not just large sculptures. They behave quite differently on their site. Contemporary large-scale sculpture has a tendency to please the site, fitting into it and somehow echoing it in form and scale. But Oldenburg's monuments disrupt the site (just as the present installation at the Castelli Gallery disrupts the gallery's space). Being disruptive and incongruent makes them dramatic and self-conscious—as dramatic or even as theatrical as a Bernini fountain. This is less the result of scale than of the specific nature of a site as well as of their iconic form. Form is identified with object. The object itself is not surprising but its identification with form and scale is. And because the object is so normal, so banal, it does not identify the form with style. Form is unidentified except by the object. These forms are then introduced into a specific site where they work as something utterly different. They carry no meaning by themselves; they are open to every meaning contemporary sentiment and knowledge may bring to them.

R. H. FUCHS

The chronicle of large-scale projects, 1977-1980 is the first book which Claes Oldenburg and Coosje van Bruggen-Oldenburg have written together.

In 1970, they met at the Stedelijk Museum in Amsterdam, where Coosje was a member of the staff from 1967-70, after having completed her studies in art history at the University of Groningen.

In 1971 she co-edited the catalogue of Sonsbeek '71 in Arnhem, and from 1971-76 taught at the Academy of Fine Arts in Enschede, The Netherlands. During that period, among other activities, she co-edited with R. H. Fuchs the catalogue of Stanley Brouwn, and did voice and translation for "Nothing to Lose," a record by Lawrence Weiner produced by the Van Abbemuseum in Eindhoven.

The collaboration between Oldenburg and Coosje van Bruggen began in 1976 on the final version of the **Trowel,** a large-scale sculpture installed permanently on the grounds of the Kröller-Müller Museum in Otterlo, The Netherlands. Since then, they have worked together on several large-scale projects such as those described in the chronicle. In 1979, Coosje van Bruggen wrote a history of Oldenburg's earlier work from the 60's seen through objects remaining from that period and collected in the artist's **Mouse Museum** and **Ray Gun Wing** (published by the Kröller-Müller Museum in conjunction with the Museum Ludwig in Cologne). Currently, she is a member of the Documenta 7 committee.

R H. Fuchs, whose contribution on the subject of monuments complements this chronicle of large-scale projects, studied at the University of Leiden, and is director of the Stedelijk Van Abbemuseum in Eindhoven, The Netherlands, and of the Documenta 7 international exhibition to be held in Kassel, West Germany, in 1982. He has written a number of catalogues on contemporary artists including Daniel Buren, Jan Dibbets, Anselm Kiefer, Ulrich Rückriem and Lawrence Weiner. He is the author of **Rembrandt in Amsterdam,** New York, 1969, and **Dutch Painting,** London, 1978.

The authors want to thank Lucy Flint, Earl Ripling and Richard Haymes for the special care given to this project.

PHOTOGRAPHS